GALWAY CITY

SNAPSHOTS THROUGH TIME

PAUL DUFFY

First published in 2014 by
CURRACH PRESS
55A Spruce Avenue, Stillorgan Industrial Park,
Blackrock, Co. Dublin

WWW.CURRACH.IE

Layout and cover design by redrattledesign.com
Origination by Currach Press
Printed by Nicholson & Bass Ltd

ISBN 978 1 78218 8384

Text: © 2014, Paul Duffy
All images from The Paul Duffy Collection

CONTENTS

Paul Duffy is an engineer who has lived and worked in Galway for the past thirty-nine years. He lectured and published extensively on various aspects of Galway's heritage and history. He has been a regular contributor on radio and television broadcasts on all manner of topics relating to Irish heritage.

Paul's postcard collection began by accident in the late 1960s and has steadily grown ever since. At present there are over 3,500 postcards in the collection.

His first book, *Galway: History on a Postcard*, was published by Currach Press in 2013.

This book could not have been published without the support and encouragement of my wife, Mary, and our family for which I am grateful. I also wish to acknowledge the patience and support of all at Currach Press. Finally I wish to thank Patricia Delaney who converted my – sometimes illegible – handwriting into a readable typescript.

INTRODUCTION

This book, which deals with Galway city and Salthill, is intended as a companion volume to the author's *Galway: History on a Postcard*, which dealt with the county. The volume is set out to follow a tour around the city. In so far as has been possible, use has been made of cards produced by local businesses. The illustrations have been selected to illustrate changes in the city streetscapes and environs over the period of 1890 to 1950, with some mid-1960s cards added. The Jimmy Walsh view of Eyre Square from c.1966 was used to illustrate how the view from the Railway Hotel of the area had changed between c.1900 and 1966. Phillip O'Gorman's view of a packed interior of the Galway Cathedral photographed on the occasion of its dedication Mass was included as it featured a milestone event in the modern history of Galway. O'Gorman first produced blank business cards in the early 1900s and meeting notification cards for the Galway Urban District Council. The firm also published cards by Laurence of Dublin, and Valentine and Sons. In the 1950s, they printed cards featuring photographs taken by the Irish Tourist Association. Another Galway firm whose work features is R.W. Simmons who set up a studio at 2 Nuns Island in 1885, later relocating to 26 Dominick Street and finally to 6 William Street. Simmon's son Albert managed the family's motor business which was established prior to the First World War and became the main Ford agents in Galway. Albert married Jeannie Hare of Newcastle, a daughter of the X-ray expert to Galway Hospital and the University, and also a postcard producer. Edmund Hill, of Dominick Street, also produced several cards prior to the Great War and set up a temporary booth in Salthill to tap into the tourist trade during the summer season. Tonery's

of Salthill post office produced cards pre-1914, whilst Cloherty's and Glynn's of Galway published cards by the reliable companies of Laurence and Valentine. In keeping with Galway's importance as a municipal and tourist destination, a large number of Irish and foreign firms also produced cards of the city. As a result of their work, we are fortunate to have a photographic record of the city and its people, which is of enormous historical value.

CHAPTER 1
Introducing the City

Over the past few years, some Stone Age implements have come to light indicating human activity in the area around what is now Galway city. No traces of any settlement from this period have been located. It wasn't until 1124 that the first recorded settlement occurred in the area. This was when the castle of Bun Gaillimhe ('Mouth of Galway River') was constructed for Turlough O'Connor. Tradition has it that, prior to this, a small village existed here called Baile na Sruthaín ('the town of the streams') because the river divided its flow through several branches to avoid rocky areas.

The river was known as Gaillimh or Galvia's River after the daughter of a local celtic chief. Galvia is reputed to have gone swimming in the river and drowned. The rock she swam from on the fateful day was, allegedly, identifiable up to the time of the first Corrib Drainage Scheme, which led to its removal from the riverbed along with many other obstructions. The commissioners of public works were supposed to have agreed to erect a monument to commemorate the event on the riverbank near the location but the cost of the drainage and navigation works went way over budget and the proposal was abandoned. Just as Galvia's River lead to the settlement of Baile na Sruthaín becoming Dún Gallimhe so the emerging importance of Lough Corrib as a trading route and defensive barrier led to Galvia's River becoming known as the Corrib.

Little is known about Turlough O'Connor's castle or its associated settlement. It was destroyed in 1132, rebuilt in 1149 and destroyed again 1161. After the Anglo-Norman invasion, Connacht was granted to Richard de Burgo, who seized the castle in 1230, lost it in 1233 and regained it again in 1235. To protect

the adjoining settlement a mirage charter was granted to the residents in 1270 by Walter de Burgo, Richard's son. This allowed them to levy tolls on a range of goods coming into the town to pay for the construction of defensive walls.

Later, charters granted from English kings gave the city rulers rights to levy tolls on a wide range of goods for not only the repair and maintenance of the city walls, but also for paving its streets. Tolls were still being levied by the urban district council well into the twentieth century, as well as rates on both private houses and commercial property. The urban council had toll houses at West Crane, Merchants Quay, Woodquay, Forster Street, Weigh House (at Eyre Square) and the Railway Gap. There was also a toll on grain which was brought in to the various mills. The total toll collection for the year ending 15 May 1913 was £1202 12s 6d. The collector's wages came to £289 15s 0d leaving a profit of £912 17s 6d. The highest earning toll house was naturally the Railway Gap with a collection of £654 10s 2d with wages outgoings of £56 5s 6d. The practices at the Railway Gap led to occasional complaints, such as that made by Mr B. Boylan of the City of Galway Woollen Manufacturing Company Ltd in November 1904. It would appear that the collectors frequently levied tolls on unsold goods being returned to the factory. Mr Boylan wanted the council to issue instructions to the collectors to cease this practice forthwith.

As the medieval city grew in size the City Corporation needed funds for various activities: maintaining a night watch; providing candles and kindling for the soldiers manning the town gates; providing entertainment for the Judges of Assize who came to Galway periodically; and, of course, paying salaries. These costs were met by levying a cess on the inhabitants. Other events such as legal actions concerning the corporation's rights and privileges were funded by special levies. The collectors were rewarded with a percentage of the collection – a practice that continued well into the twentieth century, when rates had replaced cess. Rates as a local tax on domestic properties were abolished in 1977, but have been reintroduced as domestic refuse or bin charges, house valuation tax and water rates, an altogether more penal taxation. Water rates were always controversial and regarded by many small businesses as a threat to their financial stability.

In January 1915, P.J. McCarthy, secretary and manager of the Galway & Salthill Tramways Company, wrote to the urban council concerning the impact of water rates on the viability of the company. The rates were broken down as follows: £6 0s 0d contract rate for the stables; £2 10s 0d for 'watering the rails', i.e. keeping the line clean and clear of material lodging beside the tracks; and £1 13s 4 ½d based on the

valuation of the company's premises. McCarthy wanted the contract rates for the first two items reduced as the £8 10s 0d charge was imposing 'very great hardship' on the company, which operated at a loss for eight months of the year. In September of the same year, P. McLoughlin of Cross Street wrote querying an increase in his water rates from £1 1s 8d to £1 11s 8d. There were three people in the household. He complained that he was already paying too much and couldn't really afford to pay the increase. He finished his letter by stating that he had been considering applying for reduction but concluded wistfully that 'there is not much chance now I suppose'. Some years earlier, Councillor M. Cunningham proposed a reduction in the waterworks staff; one of the 'inspectors of water waste' could be dispensed with. Obviously the improvements to the water supply system carried out after 1903 had reduced leakage, but not the charges.

The urban district council, as befitted a local body, was primarily concerned with local political matters. They did venture into national issues on occasion. In 1912 they arranged a public meeting in support of the Home Rule movement. Their support was tempered and pragmatic. When the Home Rule Bill came before the House of Lords in March 1913, Lord Killanin voted against it. The Galway Rural District Council circulated a strong condemnation of his actions and called on him to resign his seat on that body. Galway Urban District Council noted receipt of the circular. Their principal concerns related to local matters; some minor, others of major importance, such as a proposed transatlantic port. In March 1914, they were involved, along with Galway County Council, in attempting to raise the £1,000 necessary to have the Galway (Barna) Harbour Piers Bill passed through Parliament. The request for a special meeting of the urban district council to consider the matter incorporated the very local proposal that the use of Eyre Square be given to the guarantors for race weeks 1915 and 1916 for the purposes of indemnifying them against any loss the race promoters might incur. The proposal was signed by Martin Maloney, M.T. Donnellan, William Fahy, J.S. Young, F.J. Bailey and M.J. Cooke, all prominent local personalities.

Galway has a multi-layered history of local government. Prior to 1484, it was ruled or managed on behalf of the de Burgos or Burkes. With the passage of time, the town merchants gained a certain amount of freedom in running the settlement. In 1484, a charter was granted which established Galway as a city with its own corporation, which was abolished in 1840 because of incompetence, jobbery and corruption. The town commissioners had been established in 1836 to look after municipal affairs. The Galway Poor Law Union was set up in 1839 to administer poor relief and manage the workhouse. As time passed, this body took on an authoritative role in public health and sanitation. The city also had a grand jury,

responsible for various function not just for Galway but also for a part of the surrounding countryside. Its official title was 'The Grand Jury for the County of the Town of Galway'.

In 1899, the county council system replaced grand juries. Galway town acquired an urban district council, whilst its rural hinterland became part of the Galway Rural District Council, subordinate to the county council. The rural district council took over the functions of the poor law guardians, and as such, carried out works within the urban area. The rural district council were responsible for the management and maintenance of the two urban cemeteries and recouped the costs from the urban district council. The rural district council was in charge of the workhouse. In 1925, the rural districts were abolished and their duties and powers transferred to county councils. The poor law guardians' responsibilities were transferred to the Board of Health and Public Assistance under the control of the county council. In 1942, the board was abolished and the county council assumed full control of its duties. The workhouse was converted into the Central Hospital, which in turn became the site of University College Hospital. When the current hospital was constructed between 1955 and 1956, the old workhouse was demolished. The card featured in this chapter was sent to the Clerk of the Crown and Peace, now the District Court Offices, requesting documents for the most important event in a politician's term of office – an election.

Novelty composite view card, c.1905.

Composite view card featuring scenes dating from the 1920s to the 1940s.

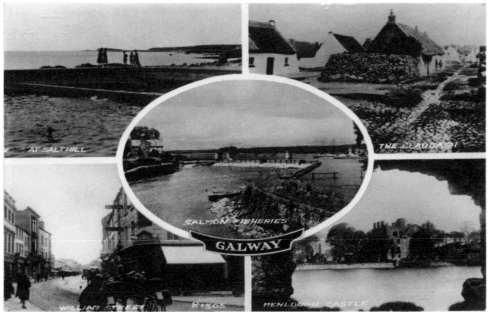

Composite view card featuring scenes from the late 1930s.

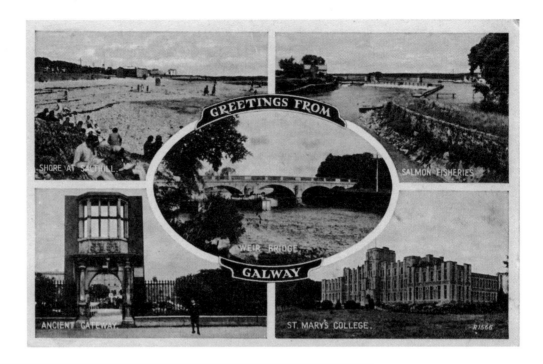

GREETINGS FROM

SHORE AT SALTHILL

SALMON FISHERIES

ANCIENT GATEWAY

WEIR BRIDGE

GALWAY

ST. MARYS COLLEGE.

R1566

Town Clerk's Office,

Galway, 15th October, 1912.

Dear Sir,

I beg to notify you that at the Meeting of the Council, to be held at the Board Room, County Buildings, Galway, on Thursday 17th October, at the hour of 12, noon, the Report of Committee recommending that Water Rates as follows:—

Public Water Rate, at 3d. in the £ ;

Domestic Water Rate, at 10d. in the £ ;

Contract Water, as per Lists,

Be made, will be submitted for adoption.

Yours faithfully,

T. N. REDINGTON, Secretary.

Galway Urban District Council notification of meeting to discuss water rates, 1912.

Galway Urban
District Council
notification
of meeting
to consider
rates, 1914.

Urban District Council Office,

Galway, 15th April, 1914.

Sir,

I beg to inform you that at the Adjourned Monthly Meeting of the Galway Urban District Council, to be held at the Council Room, County Buildings, Galway, on Thursday, the 16th instant, at 12 o'clock, noon, the Report of Committee recommending that rates as follows be made for year to the 31st March, 1915: —Poor Rate, 5s. 4d. in the £; Paving and Repairing Rate, 2s. in the £; Town Improvement Rate, 1s. in the £; Sanitary Rate, 6d. in the £. Tenders for Supplies will also be considered.

I am, Sir,

Your obedient servant,

T. N. REDINGTON, Secretary.

Urban Council Office, Galway.

25th JULY, 1912.

SIR,

I beg to inform you that a Meeting of the Galway Urban District Council will be held at the Council Room, County Buildings, Galway, ON FRIDAY, the 26th inst., at the hour of 7 30 p.m., for the purpose of making arrangements for the holding of a Home Rule Meeting on the 15th August.

I am, Sir,

Your obedient Servant,

T. N. REDINGTON,

Secretary.

Galway Urban
District Council
notification
of meeting to
arrange Home
Rule meeting.

Galway Poor
Law Union
business card.

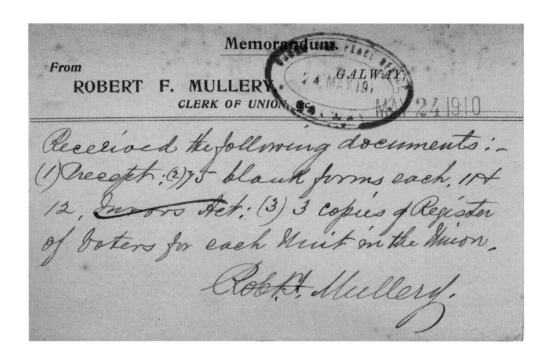

CHAPTER 2
Round the Square

In the late sixteenth century, the large open area outside the east gate of the city's walls was known as the 'Greene'. This provided an area of open ground outside the city walls which had to be crossed by people approaching the city. Enemies could be identified before they reached the city gate and dealt with; potential attackers had no cover to shelter them from defensive fire from the inhabitants. The area also served as a fair green on occasion. In 1630 'the square plot at the Green outside the east gate was set apart for the purpose of public amusement and recreation'. The area was fenced by Sir Valentine Blake, then mayor, and had ash trees planted along the boundaries. The area was used as a training ground in the seventeenth and eighteenth centuries. It also had a public gallows, which was later relocated. In 1801, General Meyrick, the military governor of the town, had a handsome square of two acres laid out and enclosed with walls to be used as a parade ground for soldiers. It became the promenade area for the *beau monde* of the city who could parade publically in their latest fashion. The city fathers renamed the green Meyrick Square as a tribute to the general.

James Meyrick was born in Eyton Court, Hereford. He joined the British army in 1779 and saw military action in the Caribbean in 1782. He married the daughter of Lord Keppel. She inherited a large fortune on the death of her father. Meyrick enjoyed rapid promotion in the army, and was sent to Ireland with the rank of brigadier general after the outbreak of the 1798 rebellion. He captured Wexford from the insurgents and subsequently became military governor of Clonmel before coming to Galway. Following a further promotion he left Galway in 1803. He died at his son's home in Berkley Square, London on 5 June

1830. The Meyrick connection with Galway was resumed in 1824 when his nephew married a Catherine White of Upper Dominick Street. The family name died out as a place name in Galway by 1840, only to be revived when the Railway Hotel was renamed the Meyrick.

From the 1820s onwards, people had reverted to calling the green Eyre Square and eventually officialdom followed suit. Edward Eyre Snr, a Cromwellian planter, was granted a ninety-nine year lease on the green by the City Corporation in 1670. His son, Edward Jr, got a sweetheart deal on the green in 1712 from the city fathers. He was mayor that year. He surrendered about a quarter acre of ground to the corporation and, in return, had the lease altered from a ninety-nine year term to a perpetual lease. This meant that the Eyres could sublease substantial building lots when the city began to expand outside the town walls.

The ongoing development accelerated about 1800 and the area around the square became prime real estate. Various hotels were constructed: the Clanrickarde Arms, later renamed Kilroy's, in 1810; and Mack's, later Black's Royal Hotel. Another hotel was located on the corner of Costelloe Lane, later called St Patrick's Lane. In 1823, William Matthews announced the opening of his new hotel, The Grey Horse and livery stables, which were sited at the 'junction of College Road and Meyrick's Square'. This section of College Road was later renamed Forster Street. The Grey Horse was built by Edward McDonnell and the proprietor promised that the prospective customers would find that the beds and rooms were well aired. As a boost to business, Matthews' operated as the terminus for the Galway to Limerick coach service. This seems to have given the impetus to develop the square as a major transport terminus. In 1855, the Bianconi Coach Service leased Kilroy's Hotel and adjoining properties for their Galway transport hub. Kilroy's Hotel later passed to the Webbs and after them to the Murphys before finally being taken over by the Delaney family as the Imperial.

Bianconi's arrival in Galway occurred within a few years of the completion of the Great Western Railway Company's line to the town. The railway company initially intended to construct their station in the Renmore area, possibly to avoid the heavy construction costs involved in building an embankment along the slob lands at Lough Athalia with its associated bridges. There was also the consideration of the British Military examining the prospect of acquiring land in the area, which finally occurred in 1862. The railway was constructed on a baronial guarantee, which meant that a public subsidy had to be paid towards the cost of running the line. In 1873, the Aran Islands were levied to pay £7 0s 8d cess, or local taxes, towards the operation of the railway; the county as a whole was taxed £9,591 19s 8d in this regard. No doubt

with such a guarantee in place it simplified the decision regarding the location of the station. The Eyre Square terminus presented the company with the opportunity of constructing a major hotel to cater for passengers. The hotel, designed by John Skipton Mulranny, was funded by government loan of £500,000 for the construction of the line. As the loan had to be guaranteed by the various baronies that were deemed to benefit from the railway, this caused some disquiet. The matter of the guarantee was pursued so energetically that in 1854 an act of parliament was passed reducing the guarantee to £470,000. The hotel had cost just under £25,000. Perseverance can occasionally reverse a financial stroke or sleight of hand. The railway company decided on letting the hotel to suitable tenants to manage. Following a succession of tenant-cum-managers, the company took over the management of the business in 1924. Some years ago the hotel was sold to a private company and the name was changed to the Meyrick Hotel.

As the square developed as a suburb of the old town, the improvements to the green instituted by Meyrick created a major amenity for the local population. By 1840, a committee was set up to collect subscriptions to defray the expenses of railing in and planking the square. The committee was led by Canon John D'Arcy of St Nicholas' Collegiate Church. The *Connaught Journal* for 2 April 1840 expressed the hope that the local population would soon be able to enjoy 'the recreations and amusements which this square will afford them'. However, not all the activities pursued in the square were either pleasant or acceptable. The *Galway Vindicator* for 17 April 1852 carried a complaint about the 'shameful and disgusting' activities of certain people who, having doused rats in turpentine and ignited the unfortunate creatures, then proceeded to drive them through the square. Despite several complaints to the constabulary, no action was taken until the press highlighted the issue. It was then dealt with quickly. Other more peaceful and pleasant activities occurred in the square. The ongoing embellishment of the area made it an attractive venue for band recitals. The British regimental bands played there as did the St Patrick's Band after its foundation in 1904. In January of that year, Councillor F. Hardiman proposed that the local Gaelic League Football Club be given the use of the square for two hours every Sunday.

The first additions to the square's landscape were the two cannons captured during the Crimean War, which arrived in 1857. During the 1860s, the authorities feared that the Fenians might make the cannon serviceable and use them in any insurrection they might be planning. Accordingly the cannon were removed to Athlone Military Barracks only returning to the city in 1868. Some years afterwards, a bronze statue by renowned artist John Henry Foley was erected to commemorate Lord Dunkellin. Dunkellin was heir to the

Clanricarde estates and had been an MP for Galway city and subsequently for the county. He died in 1867. The inscription on the plinth recorded that the Clanricarde tenants had willingly contributed to the cost but, in fact, they had been forced to. Dunkellins younger brother, who had succeeded to the family estates, was hated by his tenants as an evicting landlord. Once the British army vacated Renmore Barracks after the treaty was signed, the statue was pulled down and dragged through the streets to the river and dumped. The following morning the statue disappeared – bronze was always a valuable commodity. The plinth was removed some years later and re-erected as the base for a memorial in Castlegar to the members of the old IRA.

In 1935, Albert Powers' statue of Padraic O'Conaire was unveiled in the square by Eamon de Valera. Vandals beheaded the statue in 1999. The head was recovered and the statue was repaired. It was subsequently removed and installed in the Civic Museum.

Space had been created within this building so that the Browne Doorway could be re-erected indoors, safe from the ravages of atmospheric pollution which has not yet occurred. Thanks to the promptings of the Galway Archaeological and Historical Society the doorway was salvaged from a ruined building in Abbeygate Street and re-erected in the square. The project was funded by the county and urban district councils and the Archaeological and Historical Society. During the revamping of the square in the early 1960s, the railings were removed, leaving the doorway standing out like a sore thumb.

In 1965, the altered green was formally named the Kennedy Memorial Park by Cardinal Cushing after John F. Kennedy who had addressed the population of Galway in the square in 1963.

Rallies and celebrations have been held in the square frequently over the past two centuries. Some of these have been non-political events such as the review of the St Patrick's Day parades. On the 1915 announcement postcard included in this chapter the St Patrick's Day parade was called a demonstration. It is doubtful if this was meant in a political or social unrest context. While the council had decided to participate in parading from the Railway Station to the square to celebrate the passing of the Third Home Rule Bill in May 1914, and also to participate in a meeting to support the Irish Volunteers, they also participated in several meetings and demonstrations in favour of the British war effort. Indeed, in April 1915, the council invited the band of the Irish Guards to Galway. A special meeting was arranged to prepare plans for a 'hearty welcome' for the band, who were to entertain the public and promote recruitment. Other more peaceful entertainments also took place in the green over the years. The Connaught Grand Provincial House Show was staged at the square from 1892 to 1895. In 1905, several councillors requested

that a meeting be called to consider the possibility of holding a horse show at the green. In 1908, the green was given over to the organisers of the All Ireland Industrial Conference and Exhibition. Carnivals were also a regular annual event. Tofts Amusement occupied the square at race week for many years. The final night of their carnival was known as the 'Bull Night', because a bull was put up for raffle, all the proceeds going to charity. The chance of winning drew in a large rural crowd to the amusements.

Bulls in the square were not a novelty occurrence. The area had been used as a fair ground for several centuries. In 1730, the corporation obtained a patent for three additional fairs, as well as several extra markets, to be held on 'the square plot next to the east gate'. Patents also existed for fairs to be held at Fair Hill, Claddagh since 1613. As the surrounding area developed into a residential and business area the fairs became a nuisance. However, the economic advantage to the local shops and public houses overrode the complaints about dirt and smells. As early as 1824, Hely Dutton complained about the dirt people had to wade through to get to the green and expressed the hope that fairs might be moved to a less objectionable situation. The fairs were for cattle, sheep and pigs and the markets were for hay, corn and potatoes. The potato market was subsequently moved to Woodquay.

The street sweepings after the fairs were dumped in Woodquay until the area was developed for housing. It was then proposed to dump the street sweepings opposite Fort Hill Graveyard until the railway company objected claiming that the stench would affect the men working in the signals cabin. Eventually a site near Nimmo's Pier was selected. In the early 1900s, several proposals were brought forward to reduce the fairs at the square to one but never got anywhere. Eventually the town engineer, Mr Flannigan, got a vote of £10,000 in the early 1950s and constructed a proper fair green on a disused portion of the old Galway–Clifden railway line at Forster Street.

There was a large open area at the top of the square which was used not only for fairs but also public demonstrations and meetings. Charles Stewart Parnell addressed the voters of Galway in 1886 and again in 1891 on behalf of Captain O'Shea. Two centuries before that, the area was used as a public gallows, according to the Pictorial Map of Galway from 1652. Some twenty years after Parnell, F.J. Bailey, councillor and businessman, proposed that part of this open space be let to Mrs O'Shaughnessy to erect a portable cinematograph 'building' located on the Prospect Hill side of the toll house. The motion was defeated at the meeting on 6 November 1913. The area became a large car parking area before finally being reconfigured as a bus terminus, and taxi rank.

Eyre Square from the Great Southern Hotel, c.1900, before the Browne Doorway was erected as the principal entrance to the green.

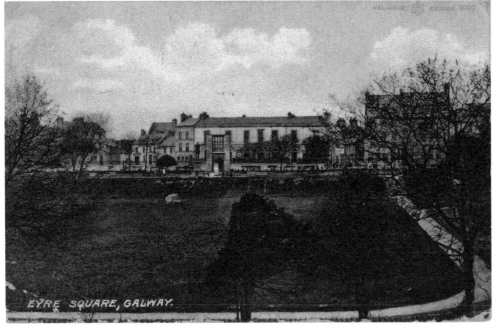

Eyre Square from the Great Southern Hotel, c.1905, after the Browne Doorway was erected at the entrance to the green. There is a large mound of snow visible at the bottom of the slope opposite the doorway.

Eyre Square from
the Great Southern
Hotel after the
1965 revamping
of the area.
The green had been
renamed the John
F. Kennedy Park.

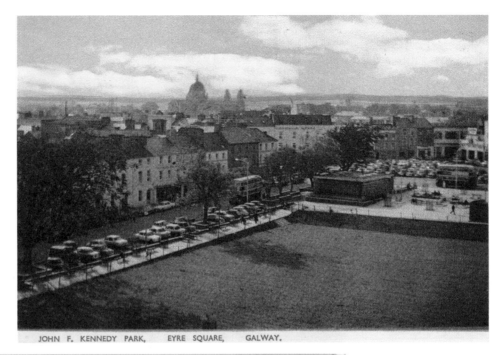

JOHN F. KENNEDY PARK, EYRE SQUARE, GALWAY.

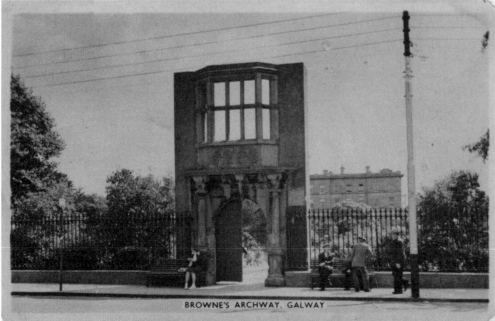

BROWNE'S ARCHWAY, GALWAY

The Browne
Doorway,
c.1955.

17

The Dunkellin
Statue, c.1905.

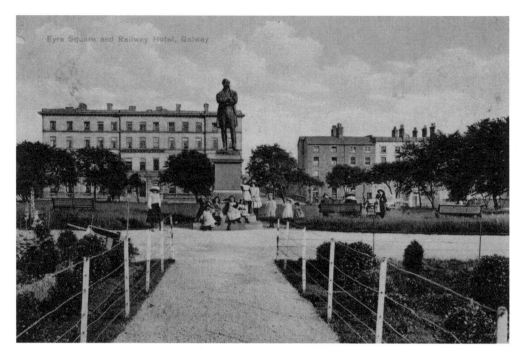

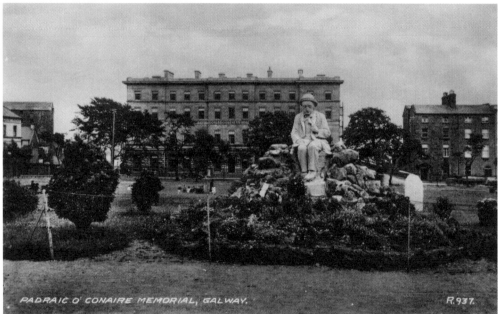

Padraic O'Conaire
statue shortly
after its erection
in 1935 with the
stone showing
no sign of
weathering.

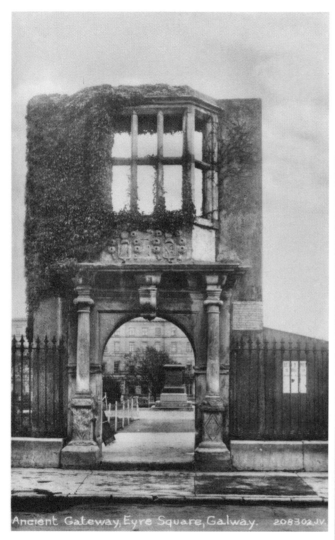

The plinth of the Dunkellin statue visible through the Browne Doorway, c.1925.

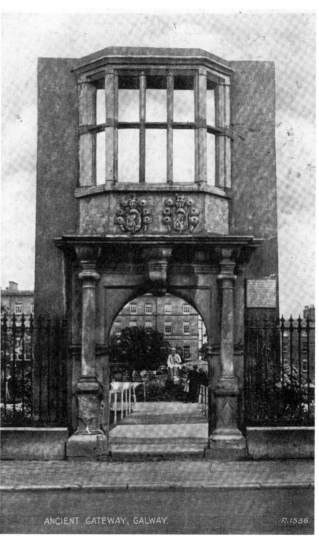

Padraic O'Conaire statue visible through the Browne Doorway, c.1935.

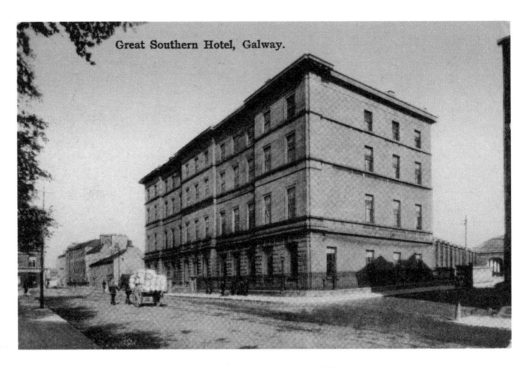

Great Southern Hotel, Galway.

The Great Southern Hotel, c.1900. The railway platform shed and goods store are visible on the right.

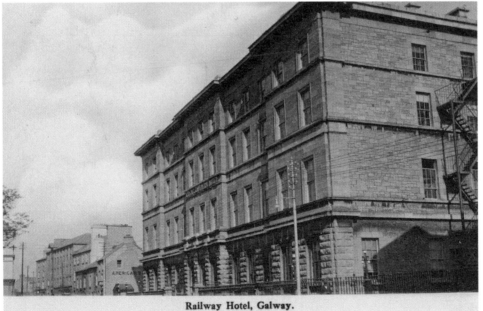

Railway Hotel, Galway.

The Great Southern Hotel and Forster Street, c.1935. The gable of the American Bar is visible at the start of Forster Street. The bar was so named because emigrants had a last drink there before beginning the long train journey to Cobh to board the emigrant ship. The roof of the toll house can clearly be seen.

Galway Urban District Council celebrates the passing of the Government of Ireland Act 1914. Before enactment the act was known as the Third Home Rule Bill. It was passed on 25 May 1914 and signed into law later in the year. Its implementation was delayed by the outbreak of war.

Urban District Council Offices, Galway,

28th May, 1914.

Dear Sir,—

The Galway Urban District Council, at their meeting held this day, decided to meet Mr. Gwynn, M.P., at the Railway Station, on arrival of the 9 o'clock p.m. train on Saturday, the 30th inst., and join in the procession to celebrate the passing of the Government of Ireland Bill through Parliament.

Your attendance is requested.

Yours Faithfully,

T. N. REDINGTON, Secretary.

Urban District Council Offices, Galway,

18th June, 1914.

Dear Sir,

The Galway Urban District Council, at their meeting held this day, decided to ask the members of the Council to attend a meeting to be held at Eyre Square, Galway, on Sunday the 21st inst at 2 oclock p m, in support of the Irish National Volunteer movement. Messrs. S. Gwynn, M.P. and W. O'Malley, M.P. will address the meeting.

Your attendance is requested.

Yours faithfully,

T. N. REDINGTON, Secretary.

Galway Urban District Council supports the Irish National Volunteers. Despite this, the enrolment in Galway was much less than in other areas of the county, such as Craughwell, for example.

21

Galway Urban District Council celebrates St Patrick's Day. Note the use of the word demonstration as opposed to parade.

Urban Council Office,

Galway, 15th March, 1915.

Dear Sir,—I beg to inform you that the Members of the Galway Urban District Council will meet at Eyre Square, Galway, at 12.30 o'clock, p.m., on WEDNESDAY, the 17th Instant, to join in ST. PATRICK'S DAY DEMONSTRATION.

Your attendance is requested.

Yours faithfully,

T. N. REDINGTON, Secretary.

To Each Member of the Council.

Carnival amusements in the green, c.1930. The amusements had their own temporary electric lighting system.

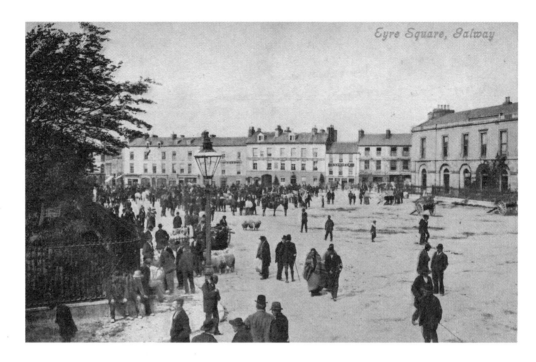

Sheep fair in the square, c.1900. Note the large gas public lighting standard on the corner.

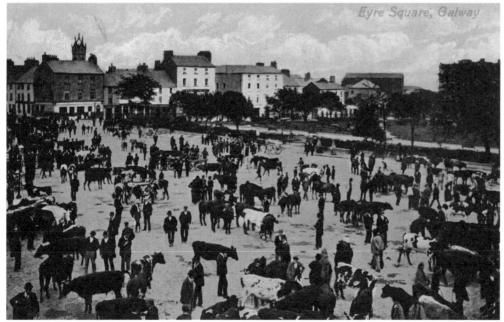

Cattle fair, c.1900. Note the Browne Doorway had not been erected when the photograph was taken.

Market day,
c.1910.
As can be seen
from the picture,
the street lighting
has changed
from gas lamps
to electric light.

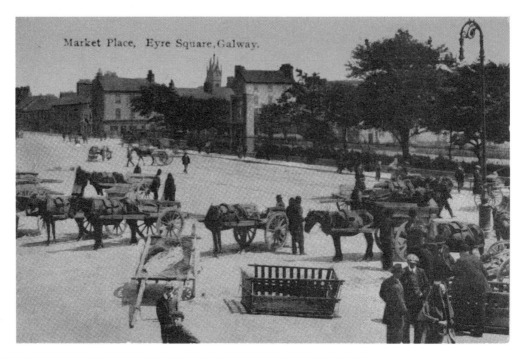

The hay market,
c.1910.
The original
photograph was
black and white but
when the printers
were producing the
coloured version for
sale they made the
hay look green.

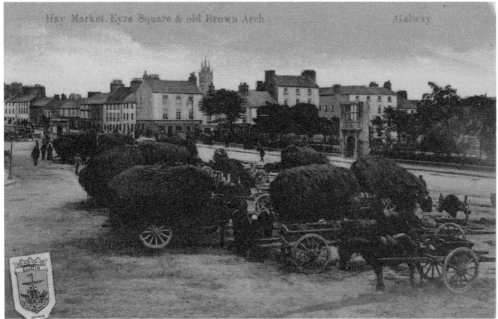

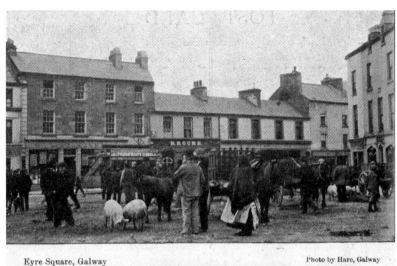

Eyre Square, Galway Photo by Hare, Galway

The pig market, c.1900.
The pig market was originally located on a large vacant area on the south-west corner of the square. The site was later acquired by the National Bank, which later became part of the Bank of Ireland Group. In the background, behind the summer tram, are Hennessey's Woollen Drapers, Hatters, and Fancy Warehousemen; Roche's public house and bakery; and McCullogh's stationers and agents for the Ordinance Survey maps.

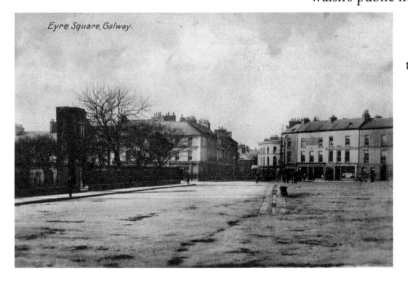

Eyre Square, Galway.

The top of the square on the morning after a fair. The building visible on the corner behind the trees was Walsh's public house. Moon's can be seen in the distance, as can the scaffolding erected for the alteration of McDonagh's shop. As one turned into the square one passed Sheil's, then Ward's Motor Cycle House, then Joyce Mackie and Co. and the Imperial Hotel. The cleanup operations hadn't begun, as the run-off channel provided to carry away the street washings shows. Some small provision for animal welfare was provided with the installation of a drinking trough in the early 1900s.

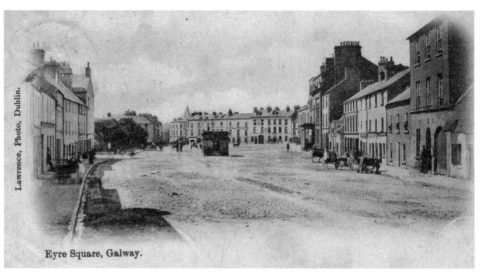

The top of the square from Prospect Hill, c.1880. The Eyre Square market toll house had been moved from its position on the corner of the green to the centre of the road. On the right is the RIC Barracks, which was vacated in 1883 when the Eglinton Street Barracks was constructed. The Prospect Hill Barracks was still in use when the photo used for this card was taken. RIC men are visible at the front door. The Prospect Hill building was acquired by a Mr Giblin, who opened a shop and public house here and later converted the building into a hotel.

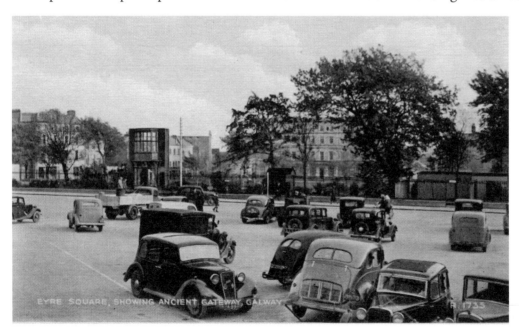

The top of the square facing east, c.1948.

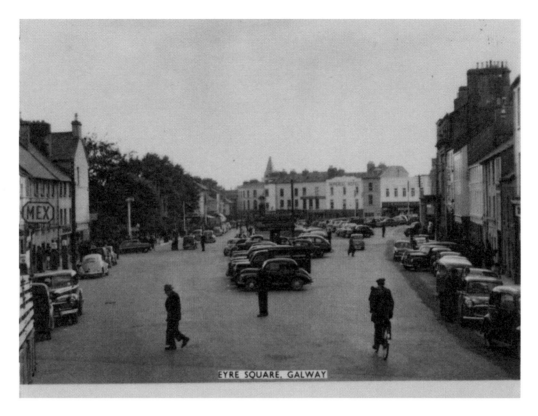

EYRE SQUARE, GALWAY

The top of the square from Prospect Hill in the 1950s.

The card must have been produced pre-1957 as the toll house had not yet been removed and replaced with the Liam Mellows Statue. The petrol pumps on the left-hand side were attached to a garage which was on the site of a coach and cart building works that was in existence in the 1870s. The 'Caltex' sign on the right-hand side was at the archway entrance leading into another small garage. The Imperial Hotel and Woolworth's can be seen in the background.

CHAPTER 3

Williamsgate Street to Shop Street

Williamsgate Street is that section of the street leading from Eyre Square to the corner of Eglinton Street. Thereafter until the junction with Abbeygate Street the name changes to William Street. Initially the street ran from the east gate straight to Lynch's Castle. However when the Cromwellians took control of the city they constructed a barracks inside the gate to control admission into the city. In 1686, a new entrance to the city was constructed just to the north of the barracks, and a new street layout outside the barrack wall rejoined the old street at the clock tower. By the time all works were finished, William III was on the English throne, hence the Williamsgate name. These changes explain the small chicane at the Eglinton Street junction, or Moon's Corner as an older generation of Galwegians called the location. Alexander Moon commenced his business career in partnership with George Farquharson in March 1858 in Eglinton Buildings. Farquharson's had been established in 1839 and originally traded from a building located where the post office now stands. There had obviously been a split in the Farquharson family at this time, as John Farquharson opened his shop at 23 William Street. He quickly changed the business name to Farquharson and Faulkner as a consequence of mistakes in delivery of business letters. The name change did not help John's company to survive. Alexander Moon took control of Farquharson and Moon sometime after 1864, and began trading in his own name. The company had an extensive mail order business and used postcards to acknowledge orders and confirm their dispatch. They also served to advertise the company. Moon's were eventually acquired by Brown Thomas who changed the shop name. The name Moon's Corner still resonates with many Galwegians.

The clock tower was constructed in 1638 and is featured on the Pictorial Map of 1652. Dillon's jewellery shop was on the site and given the fact that they also manufactured the Celtic watch they maintained a clock on the facade. Dillon's have relocated but the clock is still in position. It carries the strange inscription 'Dublin Time'. Local time was different – it depended on when the sun rose and set. The sun rose and set later in Galway than official Dublin time, which was linked to Greenwich Mean Time. For most day-to-day events, the adherence to local time made no major difference. However, trains had to run to a standardised timetable otherwise transport chaos would ensue. The timetable was set on Dublin time. Local daylight time in Galway was eleven and a half minutes behind Dublin.

Moon's Corner was on the Galway–Salthill tramway route, which also kept Dublin time to coincide with the train timetable. The tramway company was inaugurated in 1877. The single track line was two-and-a-half miles long and had eight passing loops so that trams could set out regularly and not be delayed by having to wait for the returning tram to pass. The line was officially opened on 1 October 1879 and it had cost £13,000 to construct the three-foot gauge line. Fares were set at 2d for passenger or parcel traffic. Open-topped double-decker carriages were used for summer traffic and in winter these were replaced by single-deck, covered carriages. Motive power was supplied by horses. An extra (or trace) horse was needed to haul the trams up Kingshill and served as a brake horse being tethered at the rear for the return journey, when the trams were full. Many of the company's horses were commandeered for use by the British army during the First World War.

The line finally closed in 1919. Once the tramline closed, its trackway was lifted and, accordingly, postcards showing the trams became obsolete; however, airbrushing was used to remove all traces of the tramway system, tuck up the buildings and change the clothing on the people featured in the foreground of many pictures. The new edition of the cards appeared up to date and would be saleable. The tramway lasted some forty years in service, five years longer than the Galway–Clifden railway. It featured in some of the many proposals to construct this railway. In 1881, the Galway, Oughterard and Clifden Tramways Company proposed starting their line to Clifden at Moon's Corner, crossing the Corrib via the Salmon Weir Bridge, and then proceeding to Clifden. In 1883, a Mr Winby proposed constructing a tramway from the railway station to Clifden, running over the tramway company's line to Moon's Corner and then proceeding down Eglinton Street on its way to Clifden.

After the closure of the tramway, the local horse-drawn hackneys saw an increase in business. This led to a certain amount of competition for what might have been the more lucrative pick-up points, such as outside Moon's. The urban district council introduced a system of licensing hackneys in 1912. For several years prior to this, there had been intermittent complaints about the reckless speed used by some hackneys in driving through town. Several accidents had occurred, some resulting in serious injury. Eventually by-laws were introduced to control matters somewhat.

Every carriage, coach or jaunting car had to have its licence number painted on it for identification purposes. Previously, when an accident occurred, the driver, if quick enough, could flee the scene and, unless somebody could identify him, he would get away scot-free, as happened on several occasions. Horse-drawn traffic did not cease with the arrival of motorised traffic. Córas Iompair Éireann still had horse-drawn delivery wagons in use into the 1950s. Horse-drawn trams, hackneys and delivery carts were not the only things to disappear at Moon's. The refuse collection vanished in December 1908, according to Moon's letter to Sir James O'Donohue, Chairman of the Galway Urban District Council. He complained that he couldn't get the men to take away the refuse and didn't wish to put it out into the street where it could be blown around causing a nuisance. Moon noted that all the other ratepayers in the street had their refuse collected. Maybe he forgot to give a Christmas tip! The refuse collection was later restored.

Moon's, along with many other business names, have vanished from the street. Hill's; the Empire Cinema; Sammon's Garage; 'Shoot Straight' Fallon's Butcher Shop, which became Glynn's and is now the Treasure Chest; Fallon's abattoir, which became the London and Newcastle Tea Company shop, then the New Ireland Assurance premises and later Benneton's were just some of the changes. Silke's Marian Cafe closed many years ago and Murphy's public house became Powell's. IMCO cleaners are just about remembered now, as is Grealy's Chemist shop. This business was established about 1884 by Dr Grealy, physician, surgeon and apothecary. The business was relocated to the corner of William Street and Abbeygate Street in 1889. It was claimed that the stock consisted of over a thousand patent medicines as well as Grealy's own specific treatments for the relief or cure of toothache, heartburn, sore eyes, corns, etc. He also stocked 'tonsorial applications, dentifrices, cosmetics, toiletry and fancy goods, medical and surgical appliances and household articles of many kinds'. It was claimed that prescription compounding was a special feature of the house and that only pure and fresh drugs were used.

One building that has survived the centuries, although it has been altered several times, is Lynch's Castle. The oldest part of the castle is the tower house, which dates to around 1500, and the large rectangular panel on the Shop Street facade contains the coat of arms of Henry VII, king of England from 1485 to 1509. The building was extended in the seventeenth century and the structure underwent considerable internal alterations in the nineteenth century. However, it is the facade that contains the most interesting features. One feature is a carving said to represent an ape with a child in its arms. Legend has it that the carving celebrates the rescue of a child by a pet ape when a fire broke out in the castle. At roof level there are eighteen gargoyles visible. A number of gun loops are visible on the corner facing up William Street. Given the building's current use as a bank, one can only wonder if these defensive features will see use again. By the end of the nineteenth century the ground floor was occupied by two businesses, Connolly's and Kirwin's the candle maker. The Munster and Leinster Bank bought the premises in 1918 and converted Connolly's into a temporary bank. The street facade was timber and glass. When Kirwan's vacated the premises the banking area was extended. In 1930, the banks architect, George F. Beckett, oversaw a modern restoration of the façade, which was completed in 1933 with a finely carved doorway, the work of Laurence Campbell. One of the many postcards featuring the castle shows two armed soldiers standing guard outside the timber facade.

The early postcards either looking up William Street or down Shop Street give a good idea of what the medieval streetscape looked like. They also gave some indication of the problems of living in a crowded community with unpaved streets and where horse-drawn traffic was the norm. Complaints were regularly made to the city authorities about the disgraceful condition of the streets. The best example of the official regard for the complaints is perhaps the advertisement inserted by Mayor Richard Daly in the *Connaught Journal* for 7 February 1793: 'As several respectable inhabitants have made a requisition that according to the power with which the law has invested me, I should have this town paved; I request that the inhabitants may individually pave before their doors, as each person is the best overseer to superintend what concerns him.'

The scandalous state of the streets caused a savage attack on the old City Corporation in the *Connaught Journal* for 28 July and 1 August 1825. The editor basically asserted that a £48 a year annual levy paid out of local taxes was being pocketed rather than spent on street cleaning – the purpose of the levy. The attention of the grand jury was sought to have the matter dealt with. How successful this was can be

judged from the fact that the people in the Mendicity Institute were turned out in January 1826 to clean William Street. According to the *Galway Weekly Advertiser* for 7 January 1826, the Committee of the Mendicity took the precaution of sending out the bellman or town crier to warn people of the coming clean up. It would appear that the poor had, as usual, built up large dunghills in the streets over the course of the preceding year. These dunghills were a necessity for the poor as many of them had small potato patches outside the city and the produce of the manure heaps was needed as fertiliser. As in other towns, Colraine for example, the dunghills needed to be located near the owner's residence so that they could be guarded against theft. The town crier, having assembled a large crowd of onlookers, intoned: 'This is to give notice that ye's and all of ye's to remove your dirt that ye's have dirtied or else if ye's do not, the Minister will take it all. God save the king and the Minister both.'

Who the environmentally conscious minister was is not stated, but the dunghills were cleared before the papers arrived. In due course, the old inefficient and corrupt corporation lost its powers to the Galway town commissioners and was eventually disbanded. By 1842, a contract scavenger or street cleaner named John Gleeson petitioned the town commissioners for some allowance on his contract price to maintain Cross Street. He claimed that, due to the improved state of the area, he could not collect any manure and therefore would be at a loss as he would have nothing to sell to the farming community. According to the *Galway Vindicator*, Gleeson's appeal was a source of some amusement to the commissioners.

If trams could vanish outside Moon's, then they could also disappear outside O'Gorman's (now Eason's) in an airbrushing exercise. Motorised transport was taking over, admittedly slowly. The trams were replaced by the Galway Omnibus Company's buses, which were in turn replaced by the Great Southern Railway Company's buses and, in 1948, by Córas Iompair Éireann, whose buses now trade under Bus Éireann.

Motorised delivery trucks also began to appear on Galway's streets. These were initially army surplus sold off after the end of the First World War. The solid tyres ploughed the soft nature of the city's resurfaced streets necessitating occasional steamrolling. The streets were eventually surface dressed. Now William Street, Shop Street and the Mainguard Street are paved for pedestrian usage. The buildings down the street from O'Gorman's have changed too. The old tholsel *(tólsail)*, or market and court house combined, stood on this site. It was demolished in 1822 and the stone was used to erect a new market house at the top of the square, which subsequently became the Bank of Ireland. The tholsel site was converted into market stalls or standings and eventually into a single-storied arcade of small shops. A second story was eventually

added. Directly across the road, and visible in many of the cards, is the arched entrance to Buttermilk Lane, which was known as Shoemakers Lane in the seventeenth century. It was described in 1915 as having been a much more aristocratic quarter then its battered appearance would lead one to believe. It was claimed that the area had been the recognised centre for the legal profession during the assizes and that the projecting oriel window visible in cards of the lane was where Daniel O'Connell used to sit reading before going to court. A more prosaic explanation for the window is that it allowed extra light into a tailors workroom. As one passes the Arch and turns the corner one comes to Mainguard Street, so named because of the Cromwellian barracks constructed on the east of the Great West Bridge, now replaced by the William Smith O'Brien Bridge constructed during the first Corrib Drainage Scheme.

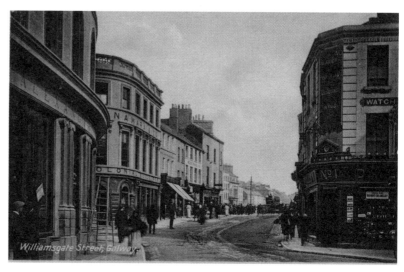

The view towards Eyre Square from Moon's Corner, c.1900. The stepladder may have belonged to a window cleaner or a sign painter. The name band over the shop was altered to read Eglinton Buildings in the early years of the twentieth century. The photograph for this card was taken on a busy market day, as can be seen from the large crowd in the background. The third building on the left after McNamara's was McDonagh's before the facade was altered.

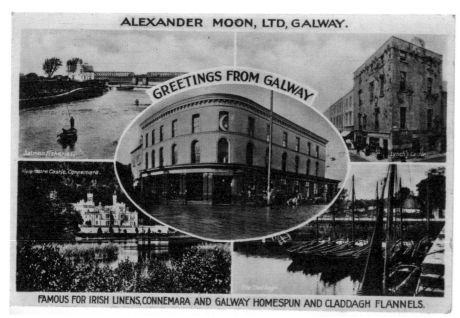

Moon's acknowledgement and advertisement card, c.1910. Alexander Moon and Company carried on an extensive mail order business. Customers' orders were acknowledged and posting of the order was confirmed using these cards. The extremely high pole for the telephone line was an urban necessity, as youngsters often tried to use the insulators as targets for stone throwing.

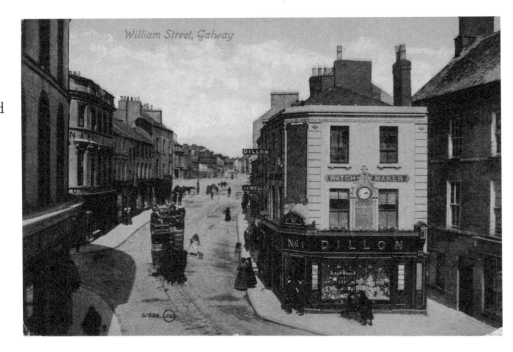

Vanishing Trams
After Galway and Salthill Tramway closed in 1919, Valentine's airbrushed the trams and tramlines from their original photographs and reissued the resultant cards with noticeably cleaner streets.

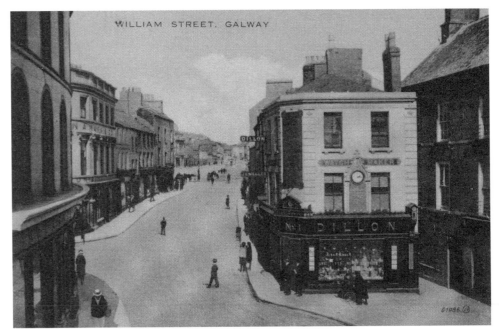

The people in the foreground had their costumes altered to the fashions of the 1920s. A little infill of the street scape was created by the addition of the two pedestrians in the foreground. This created the illusion of a new photographic card.

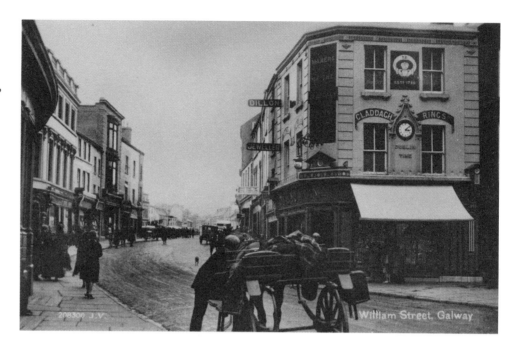

Vanishing Hackney
If trams could vanish, so too could hackney cabs. Obviously the hackney driver was not prepared to cooperate with the photographer and move his car from the road bay at the side of Moons. He had picked one of

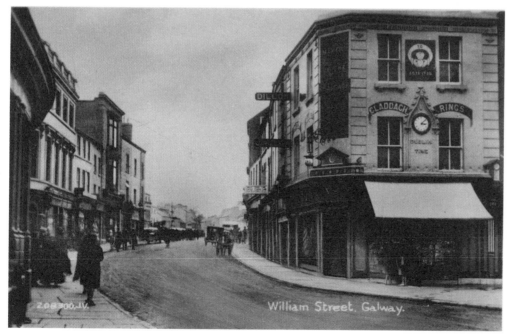

the prime stands to get a fare and was not prepared to give it up to provide a clear shot. The photographer's revenge was to have the driver, hackney car and the dog in the street airbrushed out of the picture. The clock shows the time at 3.09 p.m. in both pictures.

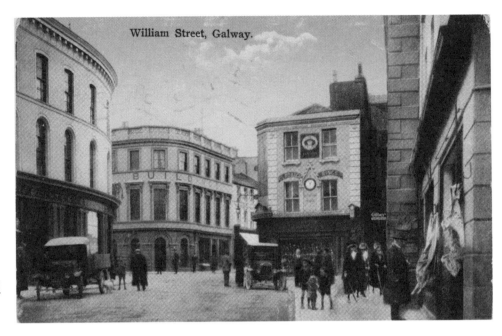

William Street, c.1920. The butchers on the right-hand side was occupied by J. 'Shoot Straight' Fallon, who also was proprietor of the Edinburgh Hotel, which was equipped with electric lighting throughout, had its own garage and charged moderate prices.

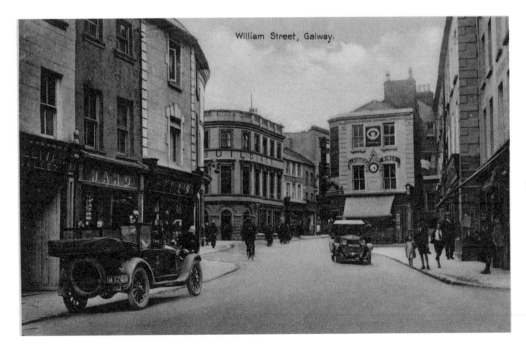

William Street in the 1930s. The registration number of the car on the left is IM 1760 and that of the other car is IM 2595. Fallon's butchers have been replaced by what appears to be a hardware shop.

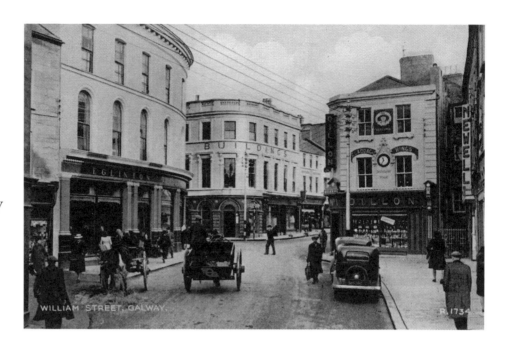

William Street in the 1950s. The Córas Iompair Éireann horse cart with its distinctive logo was used for small, local deliveries from the railway station goods yard. The logo was joking referred to as the flying snail.

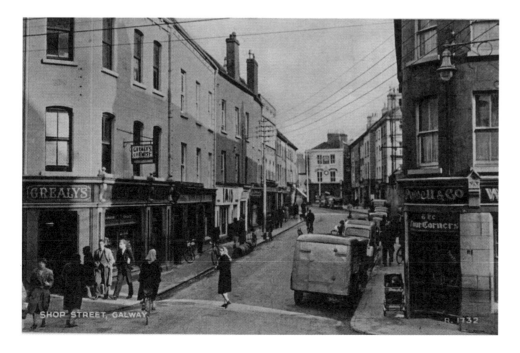

Shop Street in the 1950s. The photographs for this and the precious card were taken on the same day. Powell's had replaced Murphy's at the Four Corners on the right-hand side of the street, whilst IMCO cleaners have long since closed.

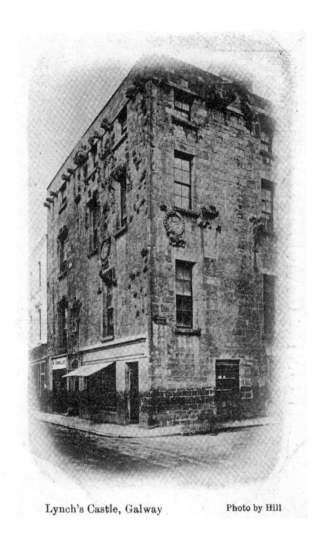

Lynch's Castle, Galway. Photo by Hill

Lynch's Castle, c.1890.
Kirwin the candle
maker and Connolly's
shop occupied the
ground floor.

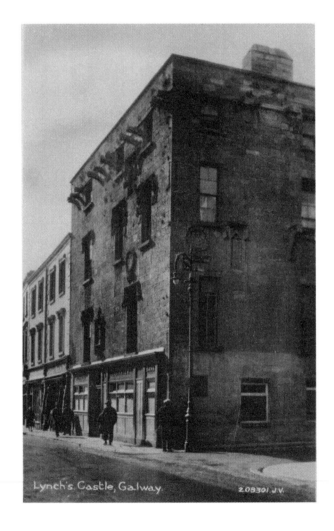

Lynch's Castle,
c.1930.
Note the timber
and glass facade for
the Munster and
Leinster Bank.

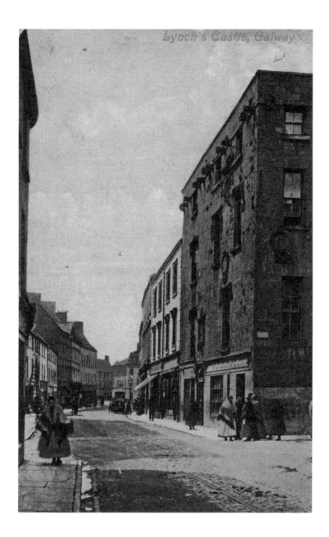

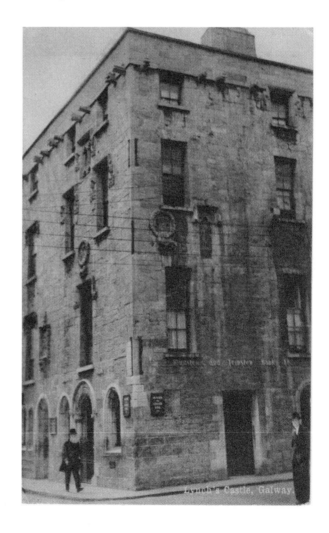

Shop Street from Lynch's Castle, c.1895. The tramway tracks with the limestone sets for the horse to walk on can be clearly seen. The fresh horse droppings on the foreground are a reminder of why the tram company needed a 'watering cart' to keep their line free from nuisance.

Lynch's Castle, c.1940. Showing Laurence Campbell facade erected in 1933.

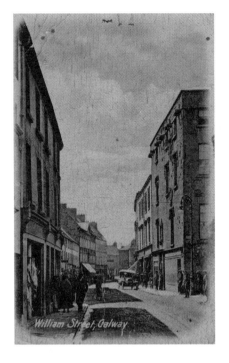

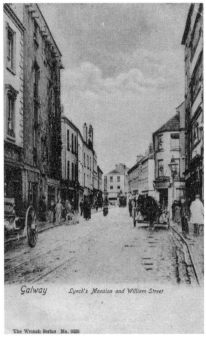

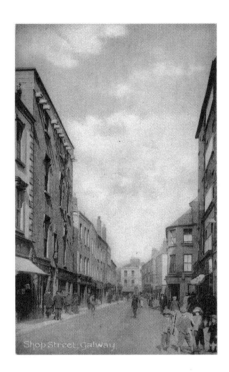

Shop Street from Lynch's Castle, c.1922.
The Munster and Leinster Bank had taken up occupation of Connolly's in Lynch's Castle and Kirwan's was closed up. There are two armed Free State soldiers at the entrance to the bank. An interesting feature of this card is that, although published by M.T. Donnellan, Shop Street, the location is described as William Street.

Lynch's Castle and William Street from Shop Street, c.1895.
The street cleaner with his barrow can be seen on the left-hand side, whilst on the right-hand side can be seen an area that needed his attention.

Looking down Shop Street to William Street, c.1910.
The tramway tracks are barely visible in this print. The gas lamps visible on the previous card have vanished to be replaced by an ornate electric light standard on the opposite side of the road. Note the contrast in clothing on the four boys at the bottom right-hand side of the photo.

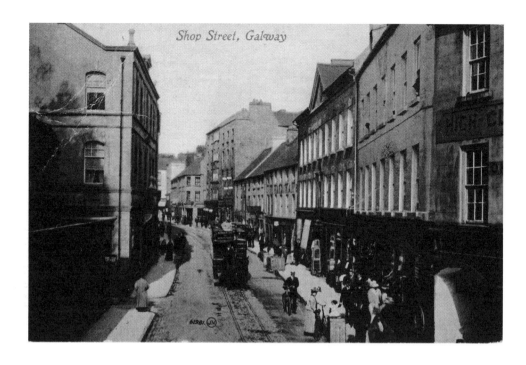

More Vanishing Trams
When the tram tracks were lifted the cards featuring trams became obsolete. Rather than waste a good photograph, the tram and tram tracks were airbrushed out of the picture. The clothing on the ladies in the foreground was

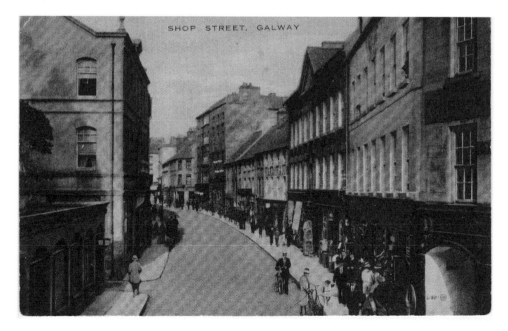

altered also. The end result was an up-to-date 1920s scene. The spotlessly clean street was part of the illusion. In reality the street surface would have looked like that shown in the card that follows.

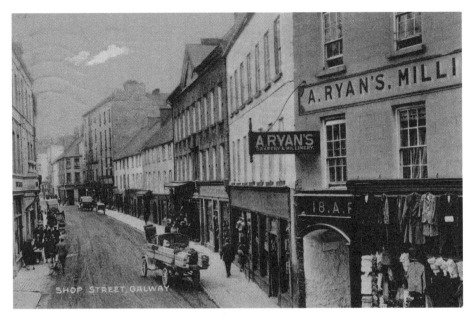

Shop Street, c.1920. The lorry was army surplus sold off after the end of the First World War. There are only two cars in the scene but the condition of the street indicates heavy usage with minimum maintenance. Further up the street from the lorry a post office parcel delivery barrow can be seen. These were in use for local deliveries until the early 1970s.

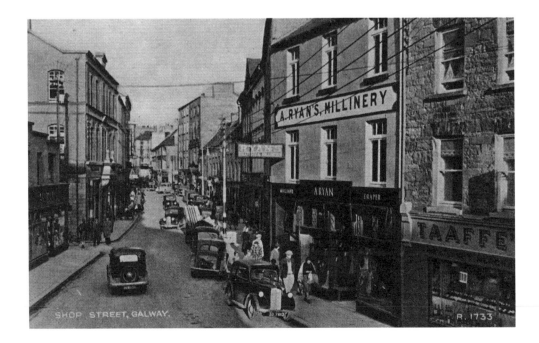

Shop Street in the 1950s, with on-street parking and two-way traffic.

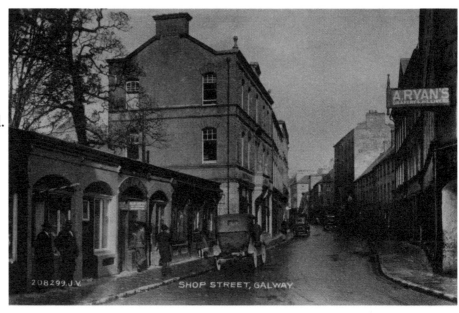

Shop Street on a wet day in the 1920s. The street was not then blacktopped or surface dressed. It had been steamrolled but not tar sprayed. Potholes had begun to develop when the photo was taken. On the left is the 'Arcade', which was on the site of the 'Standings', which had replaced the Tholsell that had been taken down and reconstructed as a market house in Eyre Square in the 1820s. It now houses the Bank of Ireland.

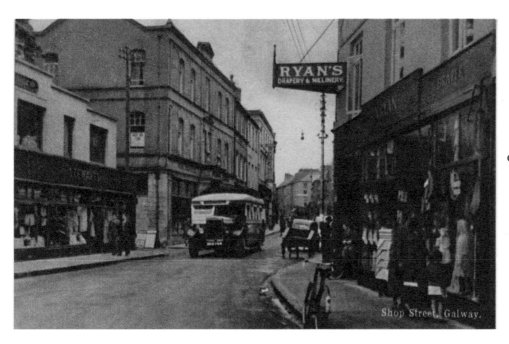

Shop Street, c.1950. The 'Arcade' had been redeveloped by this time. The photograph was taken around April or May, as Communion and Confirmation dresses can be seen in Ryan's window.

Buttermilk Lane, c.1930s, looking towards the archway exit onto Shop Street.

The bay windows were constructed to allow as much light as possible into rooms used by tailors and seamstresses.

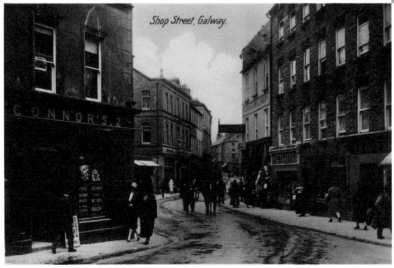

Shop Street from the corner of Mainguard Street in the 1920s. O'Connor's Newsagents also sold stationery and 'fancy' goods. They also had an office for collection of dates. The shop window carries an advertisement for Player's 'Navy Cut' cigarettes – something that wouldn't be permitted today.

CHAPTER 4

From St Nicholas' Colligate Church to the Corrib

After the Anglo-Norman colonists had secured their settlement with defensive walls, they turned their attention to religious matters. Accordingly, sometime about 1320, the construction of St Nicholas' Church began. It appears to have been built on the site of an earlier church, believed to have belonged to the Knights Templar. The major construction work of 1320 resulted in a cruciform building and later extensions and embellishments added two aisles to give the western façade its triple gabled appearance.

The tower was constructed in 1653 and the parapets were restored in 1883. During this work, the exposed timbers were struck by lightning and set on fire. The sentry on guard at the Shambles Barracks across the street called out the military fire engine and, with the help of the navy personnel, the fire was extinguished. The belfry tower had served at one stage as the town fire alarm, the bells being rung when required to summon out either the military or private insurance company's fire engines.

On one occasion a Mr Greene discovered that his mill was on fire and ran to the verges house to have the alarm bell rung. The verger refused as Mr Greene had not paid the five shilling charge the previous time he had used the alarm system. His complaint to the select vestry was not upheld.

The tower also served as the centre of the town for boundary purposes. Courthouse locations were usually used as terminus points in measuring the distances between towns but in Galway it was the spire of St Nicholas'. A kilometre stone (distance measured in kilometres as opposed to miles) in Barna features the spire of the church.

The interior of the church contains a wide variety of grave slabs, tombs and memorial inscriptions, many of great interest to the local historian. However, the most interesting memorial is the Lynch Window, a genuine nineteenth century tourist trap. Essentially, according to tradition, James Lynch Fitzstephen hung his son from the window because in 1493 his son had murdered a Spaniard for a young lady's fancy. No one would carry out the execution, so the father hung his own son. The inscribed panel refers to the skull and crossbones stone which bears the date 1621. Hardiman, the noted Galway historian, included a fanciful version of the story in his history and this became the accepted version of events. The memorial consists of a house façade that dates from the seventeenth century.

The surrounds of St Nicholas' have had a mercantile history. Italian marching bankers came to Ireland with the Anglo-Normans. They collected the papal taxes levied on the clergy and, as bankers to the king of England, collected the customs, dues and taxes. As papal bankers, they were allowed to charge interest on their loans, and when they lent money to the clergy to pay the papal taxation, they could – and did – seek the excommunication of the tardy borrower. Archbishop Thomas of Tuam was threatened with excommunication, as was the Archbishop of Cashel. From 1275 until the 1320s, the Frescobaldi and the Lombardic Bankers were collectors of the port duties and tolls in Galway. By 1340, Edward III of England owed the bankers £1.4 million, approximately €1.5 billion by today's standards. He declared himself bankrupt, thus bankrupting the bankers. The economic world didn't collapse. The name Lombard Street is the only surviving link the city has with the Italian bankers. The more modern financial dealings in the area centre around the markets. Originally a market for eggs and poultry, it grew to include vegetables and has now altered to include artisan foods, ornaments and garden plants.

Bridge Street, as its name implies, leads to the bridge spanning the Corrib. The current bridge, O'Brien's Bridge, was constructed during 1851 and 1852 during the first Corrib Drainage and Navigation Scheme to replace the Great West Bridge, built in either 1342 or 1442, depending on what expert you believe. There are references to a bridge at this site in documents from at least the very early 1400s. The old bridge was found to be in a dangerous structural condition when the riverbed was being lowered so, unfortunately, it had to be demolished. The new bridge was unofficially known as the West Bridge until it was named after William Smith O'Brien in 1889.

The boys' national school, St Patrick's, was a Patrician Brothers' school and was constructed on the site of the old Shambles Barracks. The barracks had been constructed by the Cromwellians to control

entry into the city from the west. When Renmore Barracks was opened, the Shambles ceased to have any military significance. The barracks gradually went to ruin and was acquired by the Bishop of Galway as a potential site for a new cathedral. Wiser councils prevailed, however, and the cathedral was finally constructed on the site of the former county prison.

Upstream of O'Briens Bridge, the Corrib was used to power many of the industrial sites of a former era. Some of this industrial heritage appears on postcards. Both the City of Galway Woollen Mills and Persse's Distillery feature on a view of the river. The woollen mill's site was one of the last water-powered sites to be developed in Galway; a flour mill and a bark mill were constructed on the site in the late eighteenth century. The bark mill produced tannin for the adjoining tan yard. Due to competition from the layer mills, the impact of the Famine, and the Corrib Drainage Scheme, the mills went into a decline and closed. In 1878, Bartholomew Connolly acquired the property and converted it into a woollen mill. He extended the mill in 1898. In 1906 the buildings were totally re-equipped, but the business closed in 1910. It was bought by Thomas McDonagh and Sons in 1918. They converted the buildings into a hydro-electric station producing electricity for their fertiliser plant immediately downstream of the bridge. The site was cleared in 1993 and a block of apartments erected.

Persse's distillery was located across the river. The distillery was opened in 1815 by the Joyce family who had been involved in the production of malt since the 1780s. By 1823, the Nuns Island distillery was in difficulty, but the businesses survived until 1840. Their business rivals, the Persses, bought the property and shut down the distilling operation, converting the building into a woollen mill. The extensive bonded stores were retained for the output from Persse's Newcastle operation.

A continuous series of family rows and litigation led to the distillery relocating to Nuns Island. When this occurred the woollen mill was shut down. To keep pace with their operations, the company acquired several large buildings to store whiskey. In its heyday, the distillery employed up to one hundred men, but foreign competition slowly drove it out of business. It was still shipping whiskey in 1909, sending 200 puncheons (64,000 litres) by sea to Newry Custom House. However, the company was being wound down and it was acquired by J.P. Millar who disposed of the assets over a period of years. The Nuns Island premise was later acquired by Hygia Limited. During the 1950s, the building was damaged in a fire and a new flat roof was constructed to replace the fire-damaged original.

Drainage works are not usually featured on postcards, but the Corrib downstream of O'Briens Bridge was photographed in late 1951. Walkways had been constructed out onto the riverbed to allow access for the workmen to construct dams to cordon off areas so that they could be pumped out and the bedrock excavated. The area was adjacent to the McDonagh Fertilizer Plant, which was on the site of E.C. Burke's Quarter Barrel Distillery, and is now occupied by Jury's Hotel.

Burke originally had a small distillery in Newtownsmith, where the Convent of Mercy is now located. When his brother died, he acquired the Quay Street premises in 1844. He maintained a large piggery and forty dairy cows on the site, according to an account of the premises from the 1870s. However, the business was in decline then, finally closing before the end of that decade.

Galway had a wide range of industries, most, however, have now vanished, such as brush-making. In the early years of the last century, there were two brush manufacturers in the Dominick Street area. One, a water-powered factory, was located behind the Galway Foundry site where the Garda Station now stands. The second factory was located at the lower end of Dominick Street near the canal.

Bridge Street
with St Patrick's
School on the
right-hand side.
The flat-roofed
building in the
far distance
housed the
Galway Foundry.

CHRISTIAN BROTHERS' SCHOOLS AND O'BRIEN'S BRIDGE, GALWAY

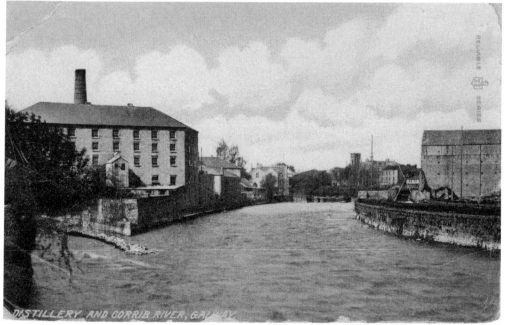

DISTILLERY AND CORRIB RIVER, GALWAY

Looking upstream
from O'Briens
Bridge.
Persse's Distillery
is on the left-hand
side and the
Galway Woollen
Manufacturing
Company's mill
is on the right-
hand side.

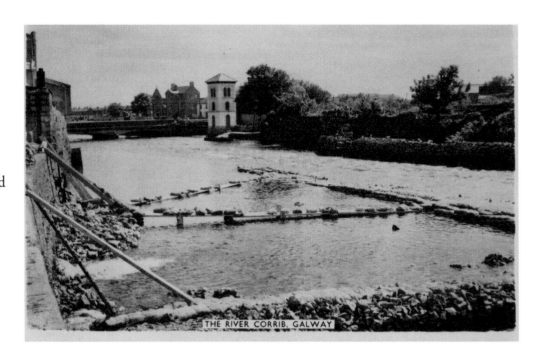

Looking downstream from O'Briens Bridge. McDonogh's Fertilizers' factory site is on the left and the tail race guard wall of Lydon's Woollen Mills and the fishery tower are on the right.

THE RIVER CORRIB, GALWAY

Company card for Galway Brush Manufacturing Company.

CHAPTER 5
The Fish Market and Spanish Arch

In the 1820s, a proposal was put forward for the City Corporation to construct a bridge linking the small fish market at the bottom of Quay Street to Feeney's March (now the Father Griffin Road area). It was intended that it be a toll bridge, but the corporation declined to act on the proposal on the basis that the tolls would never make the bridge a paying proposition. During the construction of the Eglinton Canal and the Corrib drainage works, the necessity for a temporary-access bridge at this location became apparent. This bridge had to cater for diverted traffic because of the removal of the Great West Bridge. This necessitated the construction of wide sturdy piers to carry the deck. When the construction work on both the canal and O'Brien's Bridge was completed the temporary bridge was no longer required. The bridge deck was removed but the piers were left. Because the temporary bridge had been very useful for pedestrian access to the town, the city fathers decided to construct a footbridge spanning the piers. This survived until 1887, when it was replaced by a full-width bridge on the same piers. The new iron and timber structure was erected to a design by Richard Newman Somerville. This, in turn, was replaced by the current, reinforced concrete bridge carried on the original piers. By some strange mistake, the first postcards of the area showed the 1887 bridge and a later card by the same publisher showed the first pedestrian bridge which was long removed at the time of publication (1900).

The pedestrian bridge led to greater use of the fish market area by the Claddagh women to market their husbands' catch. In medieval times, the fish market was located in Bridge Street. Gradually the market became dispersed with the women taking up individual selling points around the city streets. This created

a considerable nuisance; according to Hardiman the 'smell and filth' was insufferable at times. Eventually, in 1800, General Meyrick 'induced some of the principal inhabitants to enter into a subscription for the purpose of providing another fish market'. The chosen site was an area at the bottom of Quay Street. The new market contained several sheds, pumps, and a porters' lodge. Over the entrance to the new fish market, a plaque carried the following inscription: 'This fish market was built by a subscription under the patronage of General Meyrick, who during his residence here, acquired the praise of a grateful people for his administration of justice and benevolence.'

The fish sellers complained noisily against the new fish market and refused to use it until they were forced to do so. By 1820, they were selling their fish in the Quay Street, just outside the entrance. By 1823, the *Connaught Journal* (4 July) was carrying complaints about a 'most intolerable smell … from the fish entrails which are suffered to remain in the street in front of the fish market'. Some improvement must have taken place because by 1832 the Edinburgh Encyclopedia could state that the fish market was excellent. One nuisance endured by the fish vendors was being used as targets by some of the Claddagh boys using sling shots. The opening of the pedestrian bridge put a stop to that as the possibility of being caught and punished seems to have put a damper on their activities. For a brief period the boys turned their attention to the windows in St Nicholas' Church. Fortunately, their unwelcome attention didn't last long.

As the site of the medieval harbour was filled in and reclaimed, the fish market expanded. The new riverside walls provided extra mooring space for the Connemara fleet of hookers who offloaded seaweed and kelp for sale to the Marine Salts Company. Seaweed was also sold to local farmers for fertiliser. Significant amounts were landed for sale to the large estates in the Tuam area. The seaweed was carted to the station to be conveyed by rail to Athenry junction and onto Tuam. Following a dispute between the relevant railway companies, the Midland Great Western Railway imposed what was, in effect, an economic blockade on the Athenry and Tuam Railway Company. This killed the seaweed trade to Tuam. However, it continued well into the twentieth century for the local trade.

There was considerable pollution created in the area so much so that R.N. Somerville designed an effluent channel to carry off most of the material deposited around the area. This was regularly blocked by the wheels of carts parked around the fish market. A large concrete apron was later constructed so that the fish offal could be washed off the surface and into the drainage channels. By 1915, the situation had

become dangerous to public health according to Ruanes, who were fish carriers and importers. They also dealt in ropes, fishing line, twines and sea-fishing gear. They had a rope walk out at Two Mile Ditch and stores in Merchants Road, Long Walk and Spanish Parade. They complained about the urban district council's failure to deal with the various owners of carts who dumped them in the market area. The carts, it was alleged, were backed into Somerville's drainage channels causing them to block up. The channels stank to high heaven. Ruanes tried to hold the urban council responsible for the matter, which eventually was rectified.

The Spanish Arch slowly transformed into a tourist attraction. The 'Spanish' element of the name was taken from the nearby Spanish Parade which was originally known simply as 'The Parade'. The Arch was originally part of the town walls that was broken through to allow access to a new quay on the site of a jetty which ran out to Crow's Rock. The quay eventually became Long Walk as a result of land reclamation. The second closed (or blind) arch was in use as a forge up to the 1870s, and possibly later. The house adjoining the Spanish Arch was acquired by Claire Sheridan, the noted sculptress. Her wood carving of the Madonna of the Quays which once adorned the top of the Arch has been moved indoors to protect it from damage by the elements but still looks out onto the Quay. Her large crucifix hangs in Salthill Church. When renovating the house she installed the door surround obtained from an old mansion in Ardfry. The pillars were topped by carvings of pineapples – if you knew what a pineapple tasted like in the seventeenth century, you were wealthy. Claire also produced her own advertisement cards.

The first public bridge linking the fish market and the Claddagh, photographed prior to 1886. The large chimney was part of the marine salts factory.

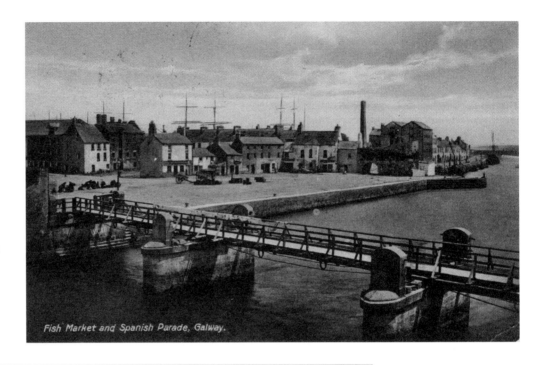

Fish Market and Spanish Parade, Galway.

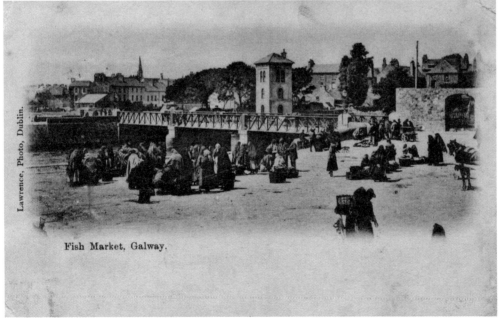

Lawrence, Photo, Dublin.

Fish Market, Galway.

The fish market looking towards the second, full-width, bridge, c.1890.

Wolfe Tone Bridge, the third bridge at this location.

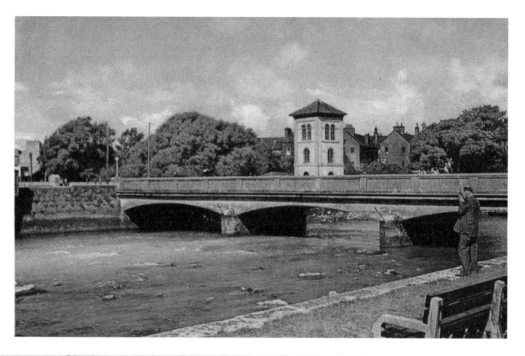

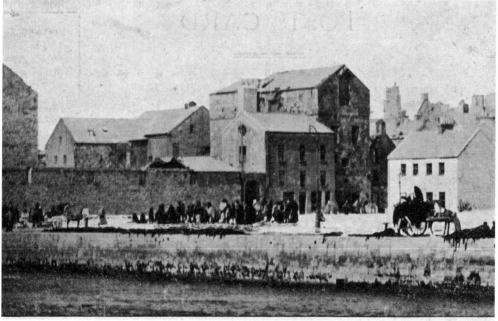

The fish market looking towards Burke's Distillery.

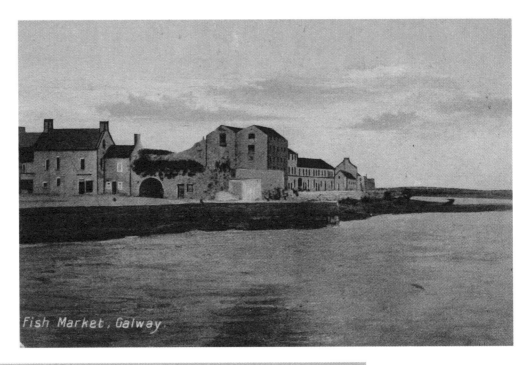

The fish market looking towards the Bond Store, later called the Kelp Store, and the Long Walk.

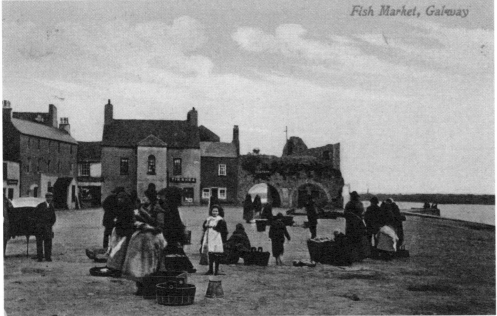

The fish market in progress, with Tim Shea's public house in the background.

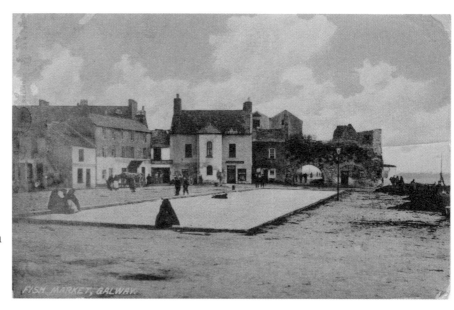

The fish market.
There are a considerable number of people visible but no market is in progress. The group of women sitting on the low wall surrounding the concreted market area appear to be having a gossip. The men on the right-hand side of the picture are offloading kelp from a hooker. The two horse-drawn carts on the left may well have been awaiting a loading from Lynskey's Rope and Twine premises, which was located in the corner beside Shea's public house.

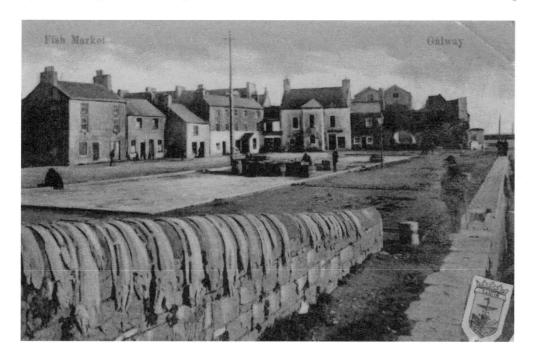

The fish market with ling drying on the wall. One of the drainage channels used to carry off the washings from the concrete market area can be seen near the man with a dog.

65

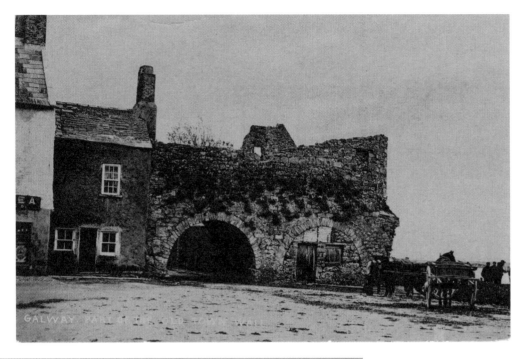

The Spanish Arch with kelp being loaded into carts.

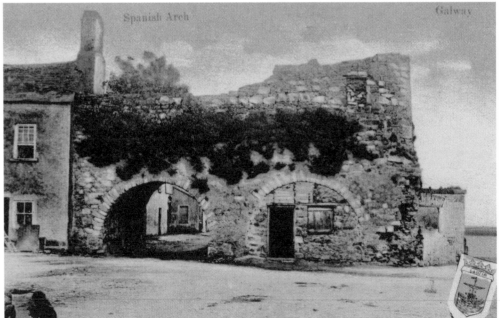

The Spanish Arch after the forge that occupied the 'blind' arch had ceased trading.

The Spanish Arch after heavy rain.

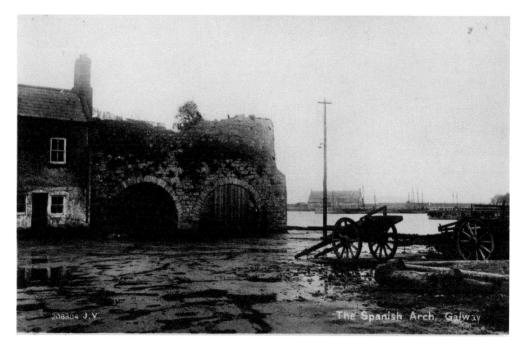

Travellers' caravans and ponies at the Spanish Arch in the 1950s.

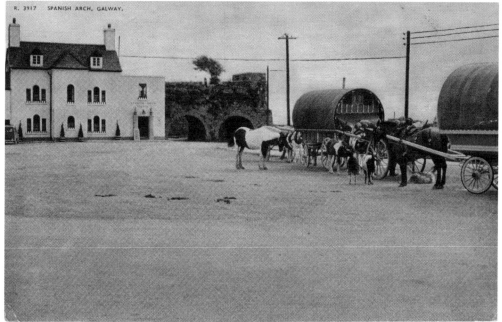

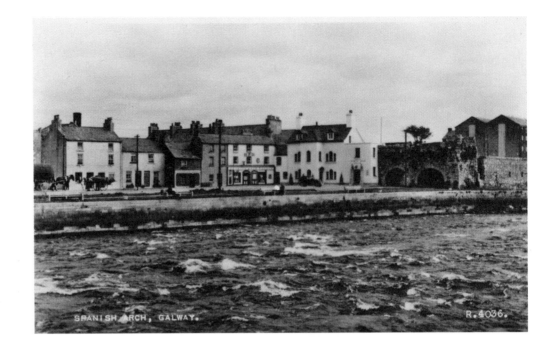

General view of the fish market and Spanish Arch. Note the traveller's caravans on the left.

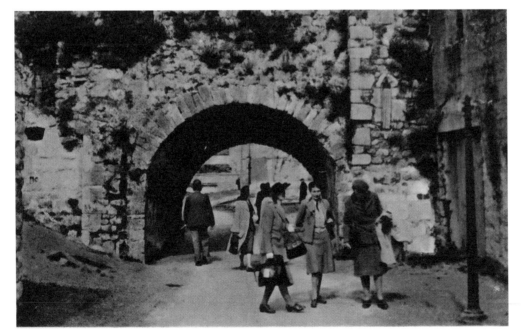

The Spanish Arch from the Long Walk.

Advertisement card for Claire Sheridan's studio and coffee shop.

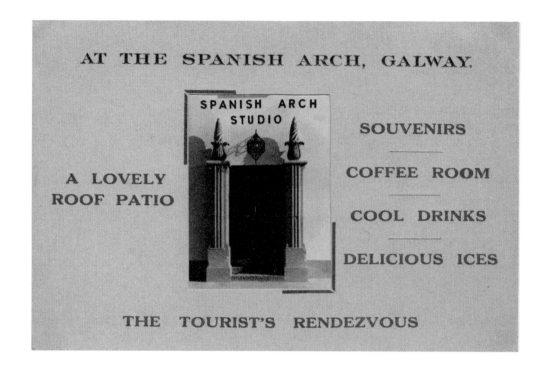

CHAPTER 6
The Turf Market, Long Walk and Claddagh

The ancient fishing village of Claddagh may be older than Galway city. It now forms a suburb of the city. The old cottages and cobbled streets were replaced by a major housing scheme in the 1930s. The Claddagh is famous for it association with the ring that bears its name. Claddagh rings were traditionally handed down from mother to daughter on the latter's marriage but sometimes from grandmother to granddaughter. Some of the earliest surviving rings can be dated back to Richard Joyce, a goldsmith who worked in Galway about 1700. Joyce had been captured and enslaved by Algerian pirates and worked for a Moorish goldsmith. When William III of England demanded the release of British and Irish slaves, Joyce was released and returned to his native city of Galway, where he set up business as a goldsmith. As the old Claddagh was a close knit community and generally married within the community, many rather old rings still survive.

Over the centuries Claddagh became synonymous with fishing, despite the romantic connotations of its ring. Another tradition was that Claddagh had its own king and his boat always had a white sail to differentiate it from the rest of the fleet. The village had its own internal rules, the king being the arbitrater of disputes. The fishing boats and the bay were blessed in mid-August at the start of the herring season and afterwards the king led the fleet to sea. The blessing of the bay is still conducted by the priests of the Dominican order who have ministered to the community since the end of the fifteenth century.

In 1820, there were some 250 boats operating out of the village, which supported some 400 households. The population was estimated at around 3,000 people. The fishing fleet was contracting in number but

the size of the boats was increasing. In 1790, the average size of the fishing boats was about 5 tons, if the row-boats were excluded. Over the next number of years the average size of the open-sail boats increased to more than double that of 1790. This would appear to be due to the construction of the *Minervia*, a 400 ton burden (cargo-carrying capacity) vessel in Galway in 1791, under the supervision of Mr Fairhurst of Liverpool. The local shipwrights would have gained valuable experience in the construction of the ship. It is no coincidence that the Claddagh vessels should have increased in size and carrying capacity afterwards.

Indeed the Claddagh boat builders built for a wider range of clients than just for their neighbours. In 1836, Pat O'Flaherty launched the Medge of eighteen tons burden, from the Claddagh Quay. Described as a very fine pleasure yacht, she was built for a gentleman living near Athlone – no doubt a member of the Lough Ree Yacht Club, which was founded in 1790 and is the second oldest yacht club in the world. There were a considerable number of yachts of between 10 and 20 tons burden being raced on the north and middle Shannon during this period. It may well be that some were built in Galway. The link between Claddagh and Lough Ree was re-established briefly in the 1990s when some second-hand púcáns were bought and transported to Athlone for pleasure sailing. The venture was not a success. Claddagh-style sailing boats were built in Parkavera between 1818 and about 1850 by Mathew Lynch and for use, it would seem, on Lough Corrib.

When the fleet returned home from fishing, the catch was divided out equally amongst the crew. The women then took control and sold the fish. The men were left with a certain amount of the proceeds, sufficient to keep the boats and gear in good condition and to indulge in a little tobacco and whiskey. The Claddagh people were, however, usually noted for their sobriety. Indeed the publicans of Athenry used to complain about the Claddagh pilgrims to Lady's Well on 15 August. Seemingly they bought no alcohol. Not only did the women folk sell the fish, but they unloaded the boats and carried the catch to market. They had several other duties also – they spun the hem and yarn to make the nets, and also made nets for sale. They also had to gather bait, worms and mussels, and bait the hooks on the long lines. However, they had complete control of the income and paid the bills. It would appear that the women folk felt that their men were not used to dealing with business and could easily be fooled. The men spent a considerable portion of their time dealing with the sea and its vagaries and had little time left for wheeling and dealing.

The religious needs of the area were tended to by the Dominicans, who came to Galway in 1488 and took possession of the abandoned Church of St Mary on the Hill. The church was embellished by Mayor James Lynch, at his own expense, in 1493. The order was deprived of its property and declared illegal by Elizabeth I in 1570 and forced to disperse. They were back in the Claddagh before 1617. In 1651, when the city was threatened by Cromwell's forces, the defenders were afraid that St Mary's would provide cover for besieging troops so they drew up an agreement with the Dominicans allowing the church to be demolished on the promise that it would be rebuilt. The church was demolished and a new one built in 1669. The community was dispersed in 1698, but some remained in the area and, despite occasional raids, the order still maintains a presence in the Claddagh. An amusing entry in the accounts book records the expenditure of 2s 2d on claret to treat the sherriff and his search party. In 1810, work was started on a new church, which was finally dedicated on 4 August 1815. This needed replacement in the 1880s, and so in 1889 the foundation stone for the new St Mary's was laid by Bishop McCormack. The building was dedicated on 25 October 1891.

As well as tending to the spiritual needs of the community, the Dominicans opened a school, the Claddagh National Piscatory School, in 1846. It catered to boys and girls, and by 1850 had 500 pupils on the rolls. As well as formal education, the boys were taught net-making and the girls introduced to lace-making. The Dominicans also tried to introduce the fishermen to new methods of fishing, but met with little success.

The unwillingness to adapt to new methods led to a serious decline in both the fishing fleet and the population by the end of the century. Even boosting income by transporting turf and seaweed into Galway from Connemara wasn't enough to stem the tide of emigration and the abandonment of the fishery. By the outbreak of the First World War there were over one hundred Claddagh men in the Royal Navy.

As the area declined in population the traditional thatched cottages were abandoned and went into decay. These cottages were constructed of mud and stone walls with a liberal coat of lime white wash. They had no running water or toilet facilities. Because of the totally haphazard and random layout of Claddagh, it couldn't be serviced with sewers. There was also the danger that some of the house walls would collapse if there were drilled through to bring in a water supply. The medical officer for the western district reported that Claddagh, due to its unsanitary condition was an 'unhealthy area' within the meaning of the Housing of the Working Classes Act of 1890. In 1929 a compulsory purchase order was made by Galway Urban

District Council and, over the following years, the houses were demolished and replaced by a new housing estate. The last of the Claddagh houses was demolished in 1938.

The rehousing programme did not proceed without incident. In 1933, the Clerk of Works reported that a number of houses that were ready for demolition had been occupied by squatters. Some councillors complained about the manner in which houses were being let by the urban council. Councillor Cooke complained that an old resident of the Claddagh had been refused a house whilst a woman who had only moved to Galway in the recent past had been given a tenancy.

Two of Galway's greatest amenities, Nimmo's Pier and the adjoining South Park are located at the Claddagh. The Pier name commemorates Alexander Nimmo, a Scottish engineer who came to Ireland as part of a group of engineers appointed by the British government to survey and report on the bogs of Ireland. After his work for the Bog Commission he was appointed to the Fishery Board and in 1822 was appointed engineer for the western district to supervise public works as part of a famine-relief scheme. When Nimmo came to Galway in 1822 the Claddagh fishermen had already constructed two rough jetties where Ballyknow and Claddagh Quays are now located. They had also cleared out the section of shore line between the jetties. As part of his proposed improvements he put forward the plan of improving the jetties and creating a quay wall to link them along the shore line. He also proposed that a breakwater be constructed at the Slate and suggested that a causeway should be built to link Claddagh to the breakwater. This would leave a large area of tidal slob land contained inside the causeway and Nimmo suggested that it would make a suitable harbour for fishing boats. Work that had been started on a pier at the slate was abandoned when government funding was withdrawn.

A fishing company had been set up in the town which employed the new style trawlers. The Claddagh fisherman attacked the boats and destroyed their nets. A gunboat, *The Plumper*, was sent to Galway in 1820 to try and bring order to Galway Bay. The Fishery Board concluded that the Claddagh men wanted a monopoly on fishing in the area and so the grants were revoked. The Plumper's presence had the desired effect and the fishing company were left unhindered. The catch improved dramatically. Government grants were restored following petitions from the mayor and MPs.

The *Connaught Journal* for 15 August 1823 reported that there was at last determination to finish the new pier at the Slate. It had been left unfinished for two years and was a disgrace to those that were involved in its construction. The pier was finished but was swept away in the hurricane of 20 November

1830. Five Claddagh fishermen were also drowned in the storm. The pier was subsequently reconstructed, and other improvements carried out under the control of McDonnell, engineer to the Fishery Board. These included the creation of a new quay and embankment between Claddagh Pier and Ballsbridge. The latter was advertised for tender on 25 June 1832 some months after Nimmo's death. When a causeway was eventually constructed out to the Slate Pier the entire structure was christened Nimmo's Pier by the local community.

The construction of the causeway led to the gradual reclamation of the tidal slop lands that became enclosed. The two streams that drained the area had to be piped out through the embankment and capped by tidal valves – the pressure of the incoming tide closed the valves and the pressure of the dammed up water forced them open when the tide was out. The major drive at reclamation came in 1905, when the urban council repaired the embankment facing Mutton Island to exclude the tide. A policy of using the site for landfill was adopted. The area was enclosed by a wall. The reclamation was a success as the council applied to the commissioners of public works to enclose the area completely and create a sports ground. By 1932, some thirty acres of ground had been reclaimed and four pitches for football and hurling had been allocated. Over the years the council had spent some £5,000 on the work. There was a caretaker employed full-time and according to correspondence with the county council the area was under continuous improvement. The county council had expressed a wish to take over the area then known as South Park to create a GAA ground. When the urban council declined the invitation to surrender the park some of the county councillors considered a compulsory purchase order. However, that notion fell through. Today South Park is open to all.

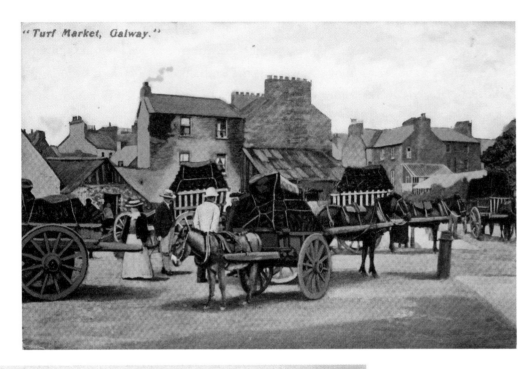

The turf market looking towards Raven Terrace and Dominick Street on the right.

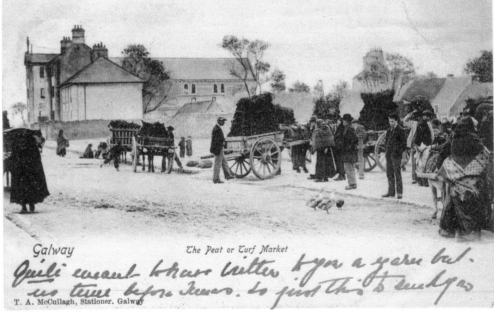

The turf market looking towards the Claddagh Piscatorial School and Church.

Fr Burke statue on site of the turf market. This photograph was taken shortly after the statue was erected.

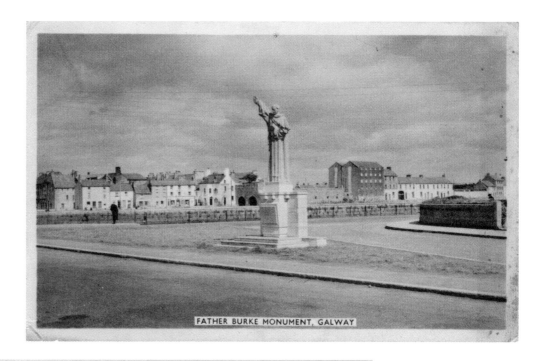

FATHER BURKE MONUMENT, GALWAY

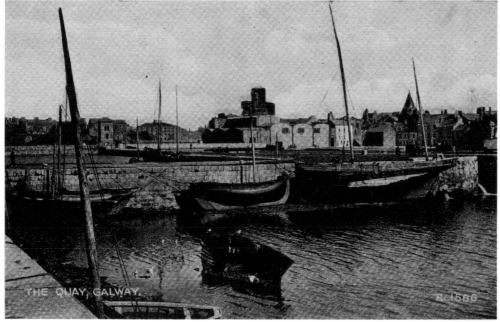

THE QUAY, GALWAY.

R. 1586

Ballyknow Quay in the 1950s. Showing the remnants of the Claddagh fleet and, in the background, the McDonogh Fertilizers' factory with its large retort house rising over every building in the city.

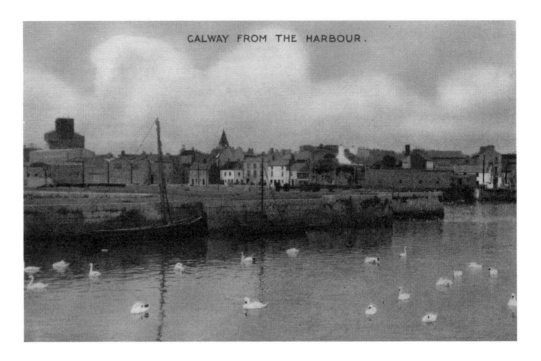

GALWAY FROM THE HARBOUR.

Ballyknow Quay and the entrance to the sea lock of the Eglinton Canal, early 1950s.

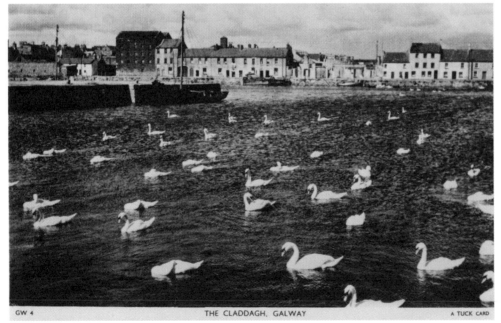

GW 4 THE CLADDAGH, GALWAY A TUCK CARD

Claddagh swans looking towards the Long Walk. There is a large construction project visible midway along the Walk.

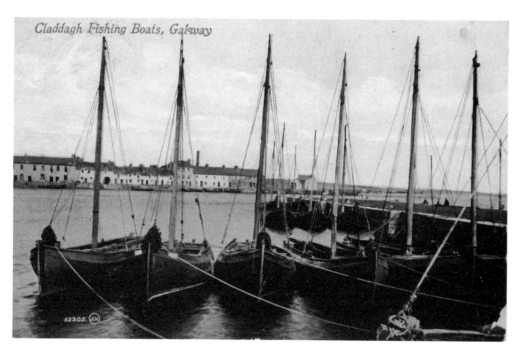

Claddagh Fishing Boats, Galway

The Claddagh fleet at Claddagh Quay looking towards the Long Walk, c.1900. The large chimney was part of the marine salts factory.

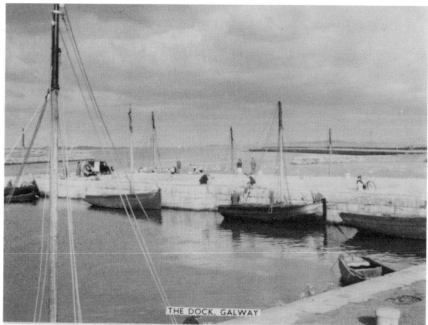

THE DOCK, GALWAY

Claddagh Quay with Nimmo's Pier in the background, early 1950s.

79

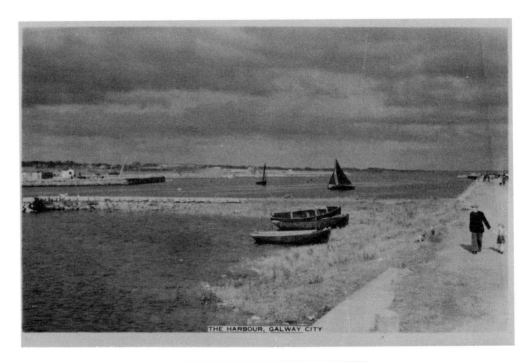

Nimmo's Pier with the unfinished quay running out into the river, c.1955. On the far bank the bend in the Long Walk shelters the Mud Dock.

THE HARBOUR, GALWAY CITY

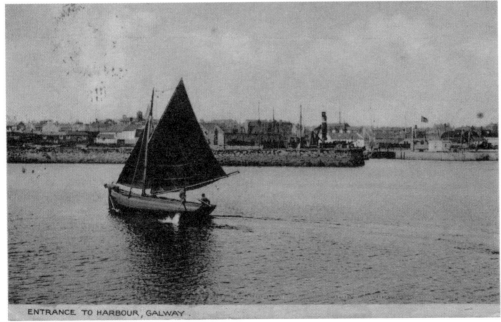

ENTRANCE TO HARBOUR, GALWAY.

The harbour. The harbour entrance is concealed behind the low wall. The high funnel of a steamer is clearly visible whilst the hooker is going about to tie up alongside the Claddagh Quay.

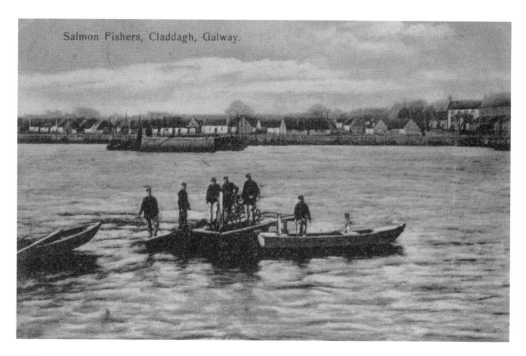

The fishery 'stage' used for drift-netting salmon by the Galway Fishery, c.1900.

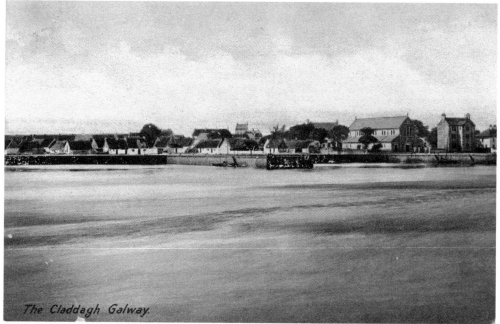

The Claddagh from the Long Walk, c.1895.

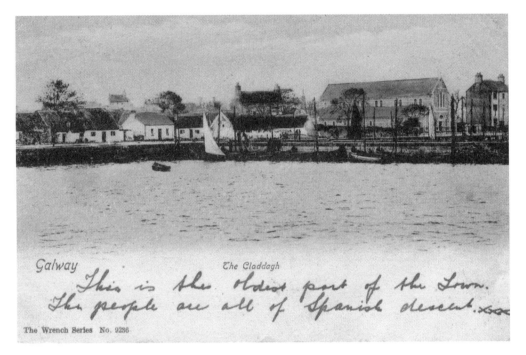

A close-up view of the Claddagh showing the white sail of the king's boat at Claddagh Quay, c.1895.

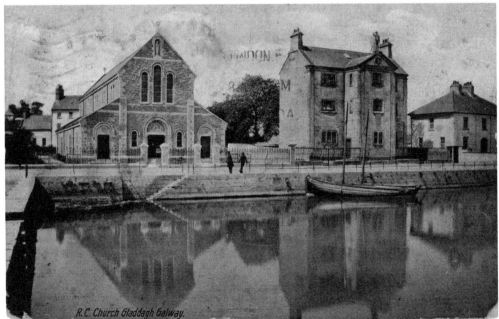

The new Claddagh Church, opened in 1891, and the Piscatorial School, built in 1846, c.1895.

The Dominican
Church, c.1895.

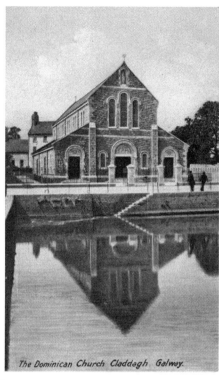

The Dominican Church Claddagh Galway.

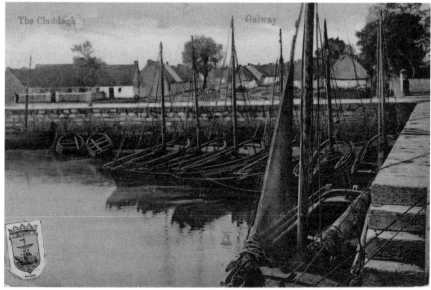

Claddagh houses
viewed from
Ballyknow Quay.
Dogfish Lane is
shown on the
right-hand side.
The gradual
decline of the area
can be seen by
comparing the line
of houses running

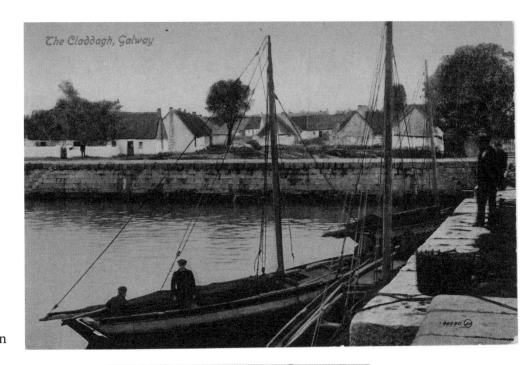

The Claddagh, Galway

inland on the left-hand side of the cards. The second and fourth houses had been demolished and cleared by the time the photograph for the third postcard was taken. The first card was posted in 1908 and the second was posted in

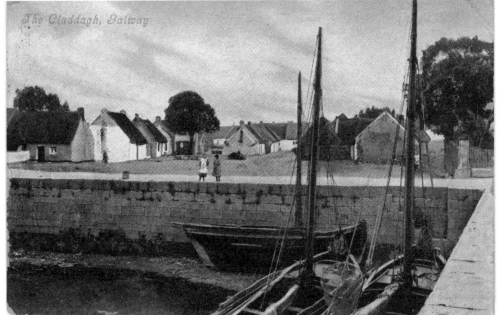

The Claddagh, Galway

Moylough in 1906. It should be noted that companies often left their cards in circulation for many years, and often used stock photographs that had often been taken many years before the cards were produced.

Claddagh fleet sailing home. The white sail shows the boat belonging to the king of the Claddagh.

Netting in the Claddagh, c.1895.

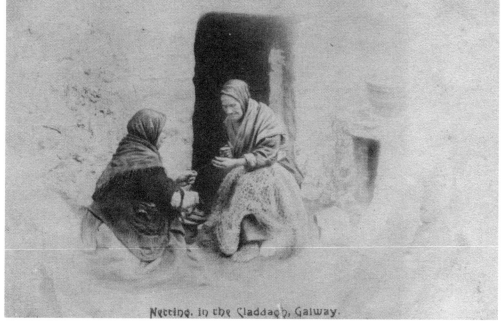

The Quays
looking towards
the Long Walk,
c.1890.

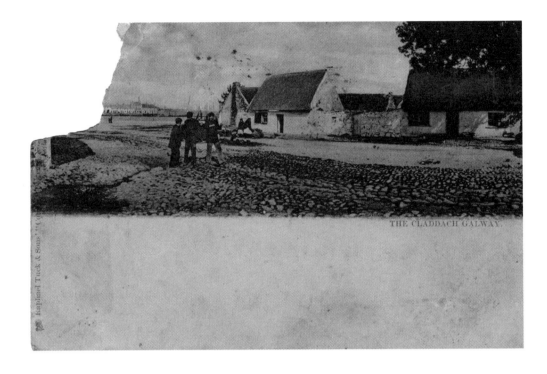

The western
end of the 'Big
Grass', c.1920.

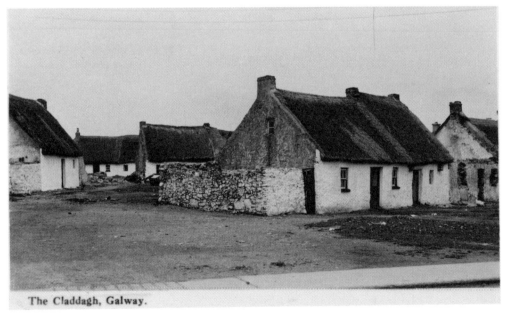

The 'Big Grass' looking towards Galway city.

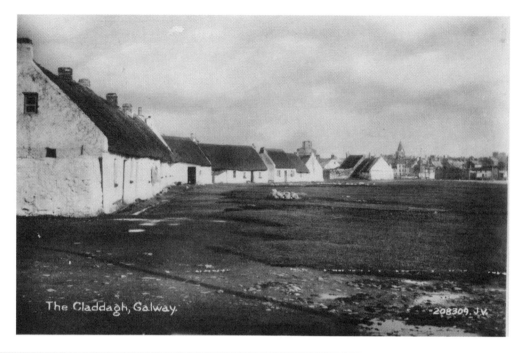

The Claddagh, Galway.

208309. J.V.

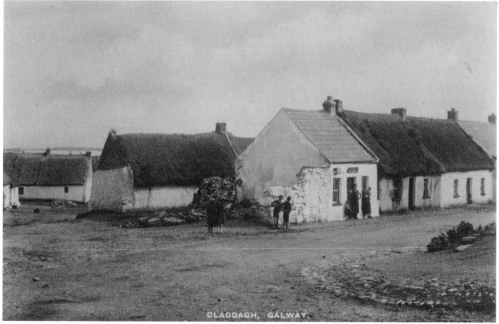

CLADDAGH, GALWAY.

The Upper Fairhill area. Note the two slated roofs, a rarity in the Claddagh, the nearest of which belonged to Lynskey, the shoemaker.

87

General view of the Claddagh, c.1910. Note the water fountain in front of the house on the right-hand side.

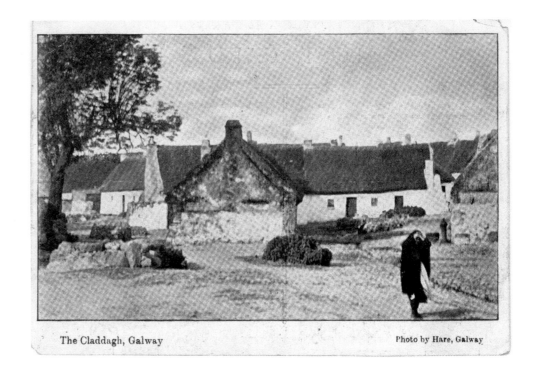

The Claddagh, Galway

Photo by Hare, Galway

CHAPTER 7
From Grattan Road to the Promenade

In the late eighteenth century, when the population of the city began to grow, it must have been extremely uncomfortable for people living in the confined space occupied by medieval Galway. By 1812, the population had risen to 24,684 people. In all, some 4,220 family units in occupation of 3,353 houses. The population had risen in the fifty years since 1762 by just over 10,500 people, whilst the area occupied by the city's housing stock had hardly increased. In 1812, the average family size was six people and surviving census data shows that the average number of people occupying houses in different parts of the city was as follows:

Cross Street	15 people per house
Middle Street	12 people per house
Playhouse Lane	15 people per house
Whitehall	13 people per house
Upper Abbeygate Street	12 people per house
Quay Street	13 people per house
Churchyard Precincts	23 people per house
Buttermilk Lane	30 people per house
Morgans Lane	40 people per house
Church Lane	19 people per house
Lombard Street	32 people per house
Market Street	32 people per house

Given the number of families crammed into some of the tenements, the lack of any form of sanitation and the number of mills, foundries, distilleries, tan yards, slaughter houses and foundrys in the town, fresh sea air must have seemed like a godsend on warm days. The 'new road leading to the Salt Water' mentioned in a to-let notice from the 1792 period is indicative of some attention being given to developing the area. The house in question was described as being new and in complete order, commanding a fine view of the bay and within a few minutes walk from the town. Another to-let advertisement from the same period mentions a house with a parlour, sitting room, kitchen, store and two bedrooms, which will be set for fortnightly periods or for the whole season.

By 1840, Salthill village had started to take shape. Salt water baths were located at Lenaboy at the start of Kingshill. There was then a gap until the start of the village proper at the crest of the hill. The village then ran downhill to where Seapoint is today and west of that there were some scattered houses and two small pre-famine fishing villages.

By the end of the nineteenth century, the village was well established as a tourist venue. This was given a further boost in the twentieth century by the song 'Galway Bay'. However, some visitors didn't realise that sunset spotting in summer time was a non-event no matter how good the weather was. The spectacular sunsets occur in mid-winter. Some postcard producers tried to capture the scene but colouring black and white images was not very successful.

The view of the village from Grattan Road captures a little of the glow of a winter sunset. Grattan Road was not named for Henry Grattan, the late-eighteenth-century Irish patriot, but for the Grattan estate who sold a section of the foreshore to the town. The new road was constructed on an embankment, cutting off a large area of tidal slob land from the sea, thus permitting its reclamation. Grattan Road intersected the Salthill Road at Lenaboy where a new house, Grattan House, had replaced the former salt water baths. The card features Grattan Lodge on a spit of high ground on the sea side of the road. Immediately beyond the house was a large open sandy area which was dry when the tide was out. This was sometimes used as a training area of British cavalry before the First World War. The ruins of Grattan Lodge were still visible in the early 1960s, a period of great change to the waterfront of the area. Seapoint Promenade was constructed to link the old promenade to Grattan Road and extended to link into Whitestrand, thus creating easier and better access to the village and extending its seaside walkway.

The opening of the Eglinton Hotel in 1860 and the Galway–Salthill tramway in 1879 heralded a new era in tourism for the village, which had become a resort. Visitors could avail of relatively cheap transport by train to Galway and the tram to Salthill. New hotels and boarding houses sprang up to cater to the demand for accommodation. The village began to expand in both directions – towards the city and also out along the coast road to the Eglinton. The old baths were replaced by the more centrally located Seapoint Baths. One of the major hindrances to the development of the area was the large area of enclosed land running all along one side of the village street. This can clearly be seen in the postcards featuring the Ballinasloe House and Seapoint Baths at high tide. During the 1930s the road was widened and the formerly enclosed land became available for development. One of the first major undertakings was the building of a church. The site chosen was at Monksfield in the centre of the old village. The foundation stone was laid by Bishop Doherty on 16 June 1935 and the church was dedicated to Christ the King on 23 August 1936. The building was altered in 1965 with the addition of two wings to the front and relocating the high alter to a central position. During this reconstruction, Mass was celebrated in Seapoint Ballroom, which had replaced the seaweed baths.

The Ballroom had opened in 1949 and the photograph for the first postcard to feature it in the landscape was taken in 1948. The simple expedient of drawing in what the finished building looked like meant that the English photographer didn't have to return and the card was ready for the 1949 tourist season. During the filming of *The Quiet Man*, John Ford arranged for the film stars to take part in a fund raising concert in Seapoint for the County Galway Volunteer Memorial Fund.

As well as being a prominent landmark on the Salthill scene, the Eglinton was the terminus of the Galway–Salthill tramway. The company was empowered by Act of Parliament to extend their line to Blackrock. On 21 May 1908, P.J. McCarthy, the company secretary and manager, informed the urban council that it wished to extend its line from the then terminus to a point nearer the promenade with a loop. This was duly accomplished, as can be seen from some cards showing the line extending beyond the Eglinton. The new terminus was outside the Forster Park Hotel, roughly where the present bus stop stands. At one stage in its history there were proposals put forward to have the tramline extended to Barna, and ultimately to Spiddal. However, this was a non-starter – the projected income would never cover the costs of the extension.

After the tramlines were removed and the volume of motor traffic increased, the road had to be surface dressed with tar and chips. One of the more unusual Galway cards shows surface dressing in operation in the 1930s. The steamroller featured in the card was eventually retired and mounted on a plinth in front of the former county buildings. When the new county buildings were under construction staff members wanted the roller to be maintained on public view in the complex. The decision was taken to send it out to Sandy Road for storage. Many years later it was given on extended loan to the Mountbellew Village Club for restoration.

Galway people recognised the benefits of steamrolling roads at an early date. The committee of Galway Races requested that the urban council steamroll the road leading to Ballybrit Racecourse in 1904. The following year their request for the same courtesy acknowledged the beneficial effect of the 1904 road rolling. Other sporting events saw some benefits to be gained from steamrolling. J. Carter, the honorary secretary of the Galway City Athletic and Cycling Sports group, looked for the use of a steamroller in July 1904. The steamroller was also sought for rolling the sports field.

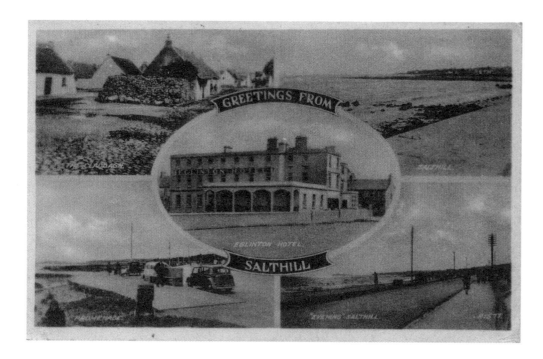

Composite view card of Salthill featuring views from the 1930s.

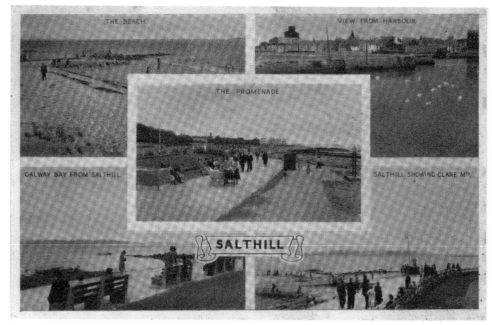

Composite view card of Salthill featuring views from the 1930s and 1940s.

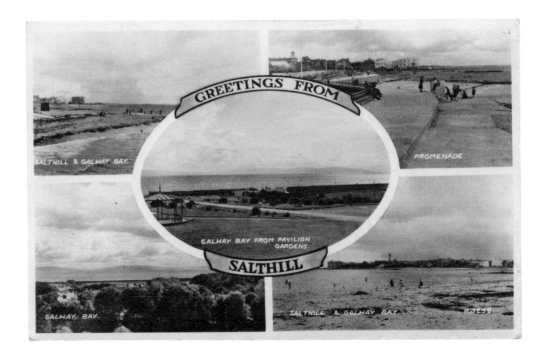

Composite view card of Salthill featuring views from the 1940s and 1950s.

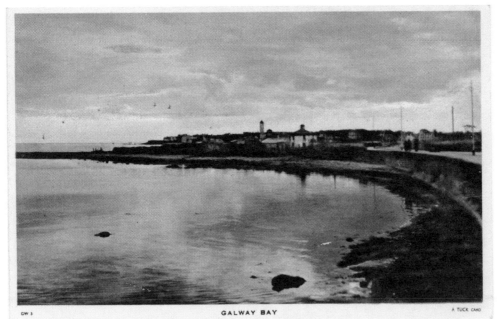

Grattan Road in the 1940s, coloured to indicate the Galway Bay sunset. Grattan Lodge can be seen in the foreground.

Salthill from
Grattan Road,
late 1930s.

Glendalough Hotel,
Salthill, c.1950.
Featured is a wedding
party. The bride and
groom can be seen seated
under the large umbrella.

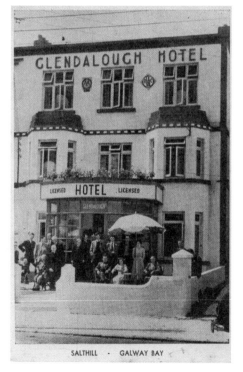

Lios na Mara
guest house,
at the start of
Kingshill, Salthill
in the 1930s.

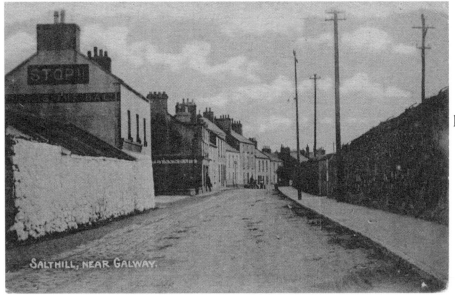

The Ballinasloe House or
'The Bal' public house.
The gable of Flynn's Bar, now
O'Connor's, can be seen at the
head of the line of buildings
leading down to the waterfront.
The tram tracks are visible
on the left-hand side of the
roadway. The high wall on
the right is the boundary
wall of the Whalley Estate.
The second pole on the right
carries an electric public light.

Salthill Church, c.1955.
In the foreground are some boarders from one of the city's boarding schools, some of whom are enjoying 'choc ices'.

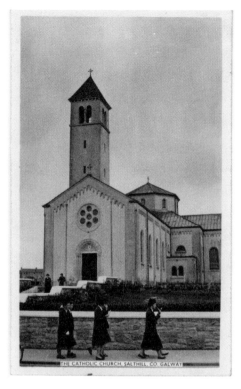

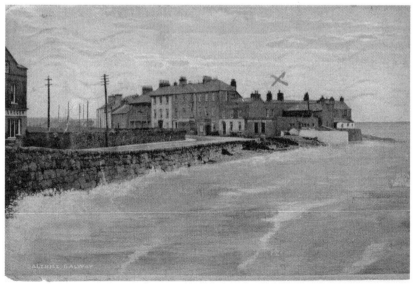

Seapoint Baths at high tide, c.1905. The fourth building located up street from the baths is Prairie House. Note its 'Wild West' style facade in keeping with its name. The road had not yet been widened when the photograph for this card was taken. The young man in front of Kenny's Grocery appears to be well wrapped up in a coat and hat which would indicate that the photo was taken in winter.

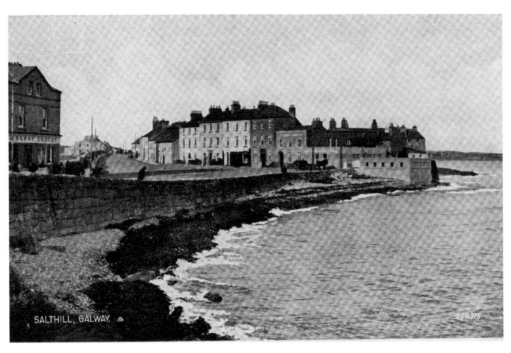

Seapoint Baths.
A similar view to
the previous card
but Prairie House
has lost its American
saloon style balcony
on the facade, and
the road has been
widened considerably.

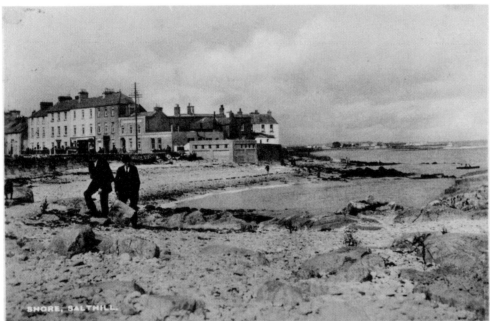

Seapoint Baths
at low tide.
The foreground has
since been reclaimed
from the sea and
made into a car park.

Seapoint Baths in the 1920s. The tramline service has been replaced by the Galway Omnibus Company's bus service. One of their buses features in the card. Keaveny's shop is clearly visible on the right-hand side.

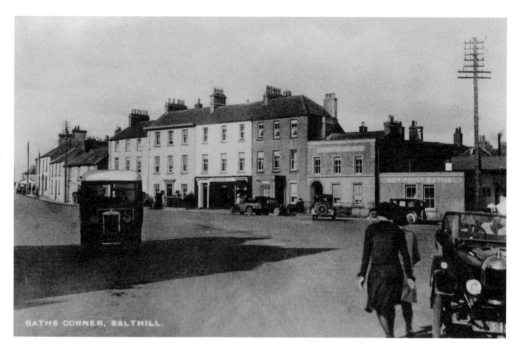

BATHS CORNER, SALTHILL.

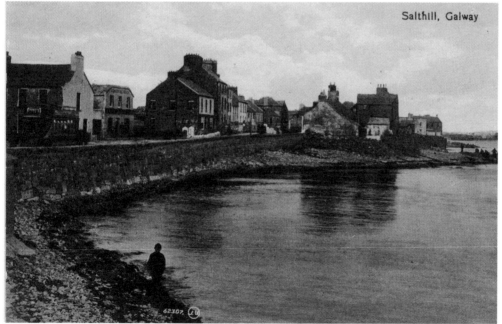

Salthill, Galway

Salthill from the Atlantic Bar towards Kenny's Grocery. The foreground has since been reclaimed from the sea. The summer tram is on the return journey to the city.

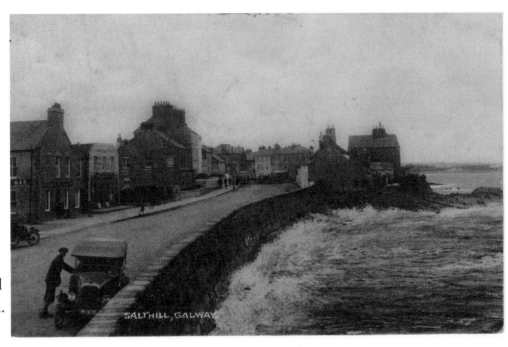

Salthill.
A similar view to the previous card but the gable of the Atlantic Bar had been altered and constructed to provide a shopfront for Donnellan's Grocery Shop. The original facade of the adjoining Commercial House bar can be seen.

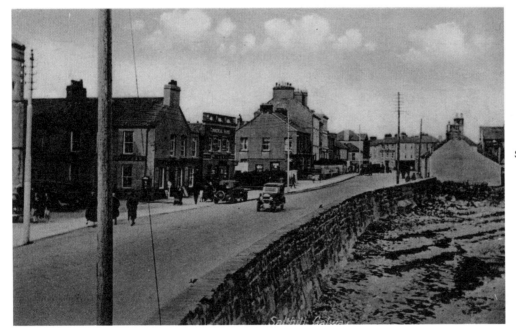

Salthill, mid-1930s. Donnellan's have added weighing scales to the street furniture. Bathroom scales were not a usual household item then. The Commercial House facade has been altered.

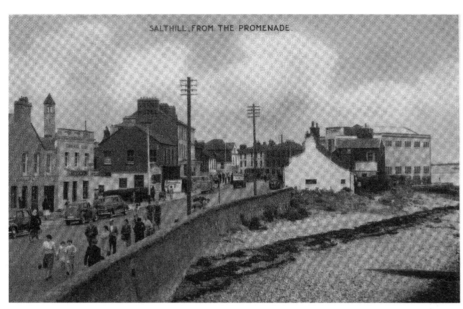

Salthill from the Promenade. The single-storied building attached to the gable of the red house on the left is the bon-bon shop. Seapoint has made an artist's appearance – being drawn in on the original photo and rephotographed. The ballroom was, quite possibly, still under construction at the time the photographer came to Salthill.

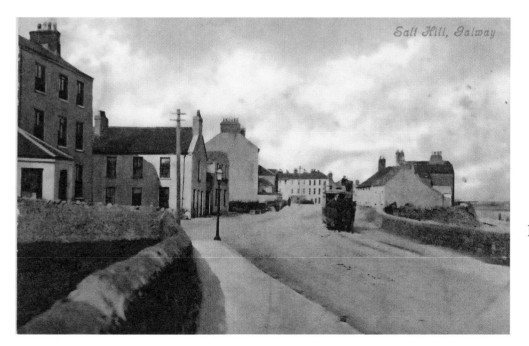

Salthill Village from the Eglinton Hotel. Note the gas light standard at the end of the footpath. There is also a large vacant site between the Commercial House and the three-storied building.

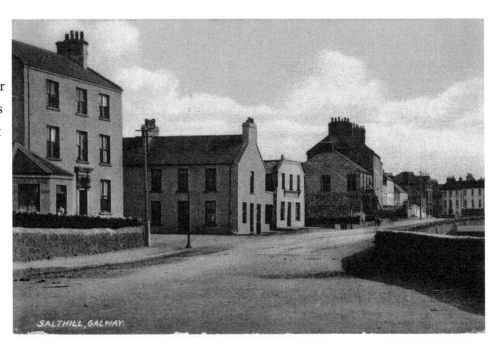

Salthill Village, c.1905. The two-story house under construction in this card is on the site that was vacant in the previous card and was later developed into the Burren Mount Hotel. The gas lamp standard has been decapitated as the town lighting was now powered by the Galway Electric Light Company.

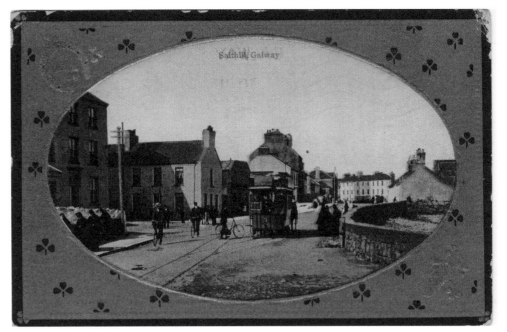

The summer tram starting out on the return journey from the terminus at the Eglinton Hotel. The stump of the gas light standard can be seen on the left, behind the cyclist wearing the straw hat.

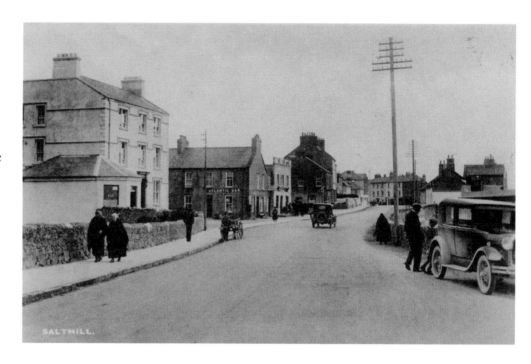

View from the late 1920s. Similar view to the preceeding card but the tram tracks have been lifted, and the facade of the Commercial House has been altered.

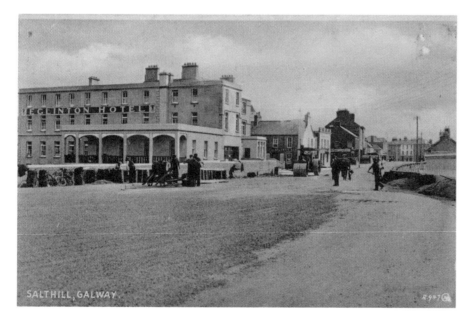

Major road works at the Eglinton, late 1930s. The tar was delivered in barrels at this point in time, hence the large number of barrels along the edge of the footpath. A group of men seem to be getting ready to load a sprayer, and the workmen's bicycles can be seen on the left.

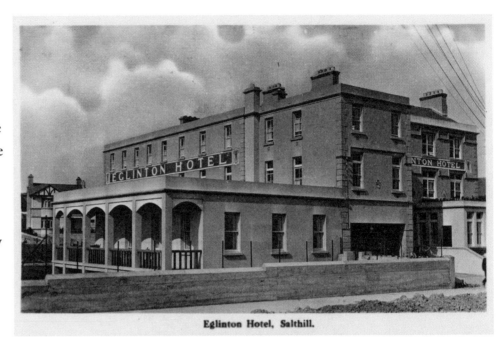

A close-up view of the Eglinton Hotel. This was probably photographed some time after the road was surface dressed. A large amount of material is mounded up along the edge of the footpath. The rather new looking boundary wall surrounding the tennis courts has had mesh fencing attached to it.

Eglinton Hotel, Salthill.

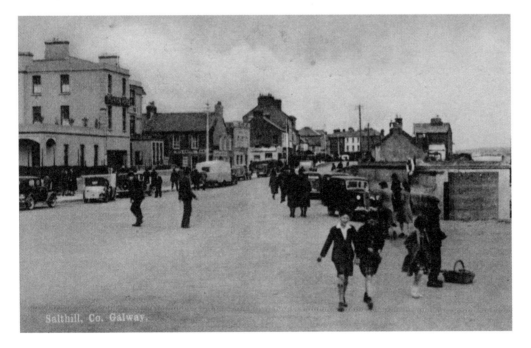

Salthill, Co. Galway.

The Eglinton Hotel, 1950s.

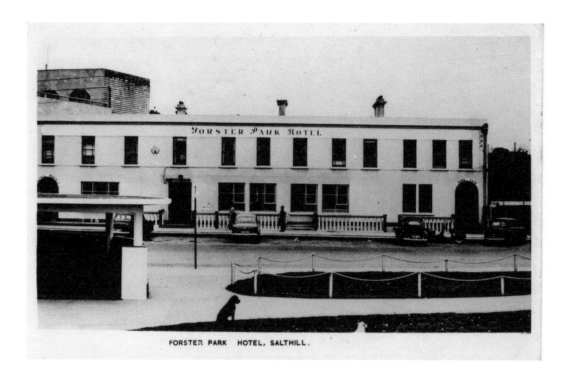

FORSTER PARK HOTEL, SALTHILL.

The Forster Park Hotel, c.1960.

Pre-1951, there were two hotels on this site. The Forster Park and the Claremont. When the Claremont was up for sale in 1951 it was acquired by the Forster Park owners who extended their premises. The hotel was on the site of a small lake, Loughainpatrick, which was drained and partially reclaimed. The Forster Park name came from the house of the same name, which later became the garda barracks. The house was originally known as Sandy Mount.

CHAPTER 8
Salthill Park and Promenade

In the years prior to the Famine there were a number of small villages located to the west of Salthill. Cappanaveagh was close to Sandy Mount House (later known as Forster Court House), and Ballynacarrickadoo was opposite Blackrock. All that remains of these villages is a vacant plot beside the road – the footprint of a long vanished cottage.

During the 1850s, much of the land in the Attithomasrevagh townland was acquired by James Henry Barton. He set about dividing up his holding into substantial plots for sale as sites for 'villas'. There were restrictions placed on the use of the land in the deeds of sale. The land could not be used as sites for hotels or religious institutions. Barton held the seaweed harvesting rights, and also the mining or mineral rights. Traces of lead had been found in the area but a 'trial' or exploration for a potential mine site proved to be a failure.

One of the first to purchase from Barton was William Burdon Blood, professor of civil engineering at Queens College Galway. Blood's pioneering work on bridge design led to the successful design and construction of the ironwork for the Boyne viaduct, which had the longest clear span in the world when opened. Blood also constructed Gurtland. Many years later the house was acquired by one of Blood's successors, a Frank Sharman Rishworth, the Tuam-born professor of civil engineering, who was also the chief state engineer supervising the construction of the Shannon Hydroelectric Scheme.

Another renowned engineer to live in the area was Samuel Ussher Roberts. Roberts designed Brinkwater House, now sadly demolished to leave a vacant site for the summer amusements. Roberts came to Galway

to take charge of the works on the first Corrib Drainage and Navigation Scheme and stayed on to become county surveyor for the West Division of County Galway. As well as designing mansions like Kylemore Castle he also designed railways. He prepared two different designs for a Galway–Clifden Railway, one in the early 1860s, the other in the 1870s.

As the demand for better amenities grew, Galway Urban District Council provided facilities on a gradual basis. Three seating sections were constructed on the promenade. This was increased to six in 1914. Public toilets were provided and the footpaths were extended and renewed.

One major item was the acquisition and development of what is now known as Salthill Park. The land was finally acquired in 1912 from a Mr Connolly and T. Costello, a member of the urban district council. Mr Connolly accepted £400 for his share of the land but Mr Costello held out for £600 initially finally reducing his demand to £550. The Dublin firm of W. Sheppard and Sons were engaged to draw up landscaping plans, and T.B. Madden of Ballymurray, Co. Roscommon was asked to supply trees that would survive in an exposed site such as the park. Madden later relocated to Taylor's Hill in Galway. Part of the work involved the cesspool that had developed in what was left of Loughan Lake after Barton's development of his lands. A baustand was erected in one corner of the park. The pillow and panels were cast in Glasgow to a standard design and assembled on-site.

The park was used for carnival amusements for a number of summers. Toft's amusements were the regular carnival. Toft's had been coming to Salthill since 1902, and possibly earlier. In the early 1900s they traded under the name 'Toft's Steam Horses and Moving Picture Shows'. The steam horses refer to the large hobby horse roundabouts that were driven by a stationary steam engine. In August 1914, John H. Toft of Eyre Square was giving 'exhibitions of moving pictures' in his booth at Salthill. So popular had Salthill become by then that Edmund Hill, the Galway photographer and postcard producer, sought to rent space for a photographic studio for the duration of the summer. Difficulties arose with noise levels from the park and, in March 1933, the council decided to terminate Toft's lease of Salthill Park and not to permit his or any other amusements to use the park that summer.

Provision and maintenance of amenities was always expensive. In 1913, it was proposed to hold a citizens' bazaar in support of the development of the area. In the 1920s, however, a novel approach was taken. A disused aeroplane hangar from Oranmore Aerodrome became available and was acquired and re-erected in the park. It was officially known as the Pavilion Ballroom, but was commonly known as the

Hangar. The Salthill Development Association rented the Hangar from Galway City Council and applied the profits raised from dancing and other activities, such as boxing tournaments, to the improvement of Salthill. The money raised, approximately £10,500, and grants received from the Tourism Development Board and later Bord Fáilte were used to clear beach areas, finish out the seating amphitheatre, and erect a new diving tower at Blackrock.

Alexander Moon is credited with the erection of the first diving board at Blackrock. The area became a popular swimming area for men. Colonel O'Hara, who owned the land in the vicinity, took exception to the bathers crossing his property to get to the diving board. He had some of them prosecuted for trespass. Eventually, the urban council negotiated a right of way and took responsibility for the erection and maintenance of the springboard on an annual basis. Problems remained, and Colonel O'Hara refused to allow the urban council to put up the diving board in 1909. Correspondence was exchanged with Fry and Company Solicitors on the matter. By mid-June the Tuam Herald was reporting that the 'very Rev. P.J. Lally, P.P. V.F. presided at an indignation meeting in Galway against the action of Colonel O'Hara in refusing the citizens permission to re-erect a springboard for bathing purposes at Blackrock, Salthill. It was determined to form a citizens committee to fight the matter at law.' Peace eventually broke out and the matter was resolved.

The early springboard was replaced by the structure shown in the card from c.1950. Following several complaints about the timbers getting slimed and slippery from sea growth, an accident occurred. An elderly lady slipped on the slimy boards and fell into the sea. A local, Laurence Craughwell, managed to save her from drowning. A new structure was decided on and constructed by James Stewart and Company to a design by Edward Ralph Ryan. The new facility was opened in 1956 at a cost of £5,500. The Salthill Development Association contributed £1,000 to the costs. A Bord Fáilte grant of £6,700 was received in 1955, the money to go towards the costs of providing changing rooms and extending and completing the amphitheatre.

Initially Blackrock was a men's bathing area, a beach being reserved for ladies and children. The mental barriers have long since broken down and the facility is open for all to enjoy.

Galway Urban District Council card. Notifying councillors of a public inquiry into the council's proposals to raise a loan to provide recreational facilities in Salthill, 1913.

URBAN DISTRICT COUNCIL OFFICE.

GALWAY, 25TH FEBRUARY, 1913.

SIR,

I beg to inform you that MR. A. D. PRICE, M.I.C.E., Local Government Board Inspector, will hold an Inquiry into the Council's application for a Loan of £1,200 for the purpose of providing a Recreation Ground at Salthill and the Purchase of Lands at Salthill, at the Council Room, County Buildings. Galway, on Thursday, 27th inst., at 11 o'clock, a.m.

I am, Sir,

Your obedient Servant,

T. N. REDINGTON,

SECRETARY.

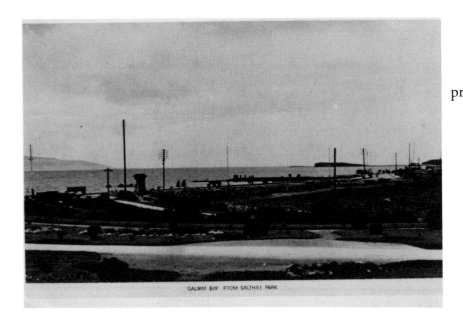

GALWAY BAY FROM SALTHILL PARK

Galway Bay from Salthill Park, c.1940. The total absence of cars on the promenade is as a result of wartime restrictions and petrol rationing. The large pillar was one of four that formed the large recessed gateway to Rockbarton Road, which was a private roadway for many years. A new wall is in the course of construction to allow for road widening once the pillar has been removed.

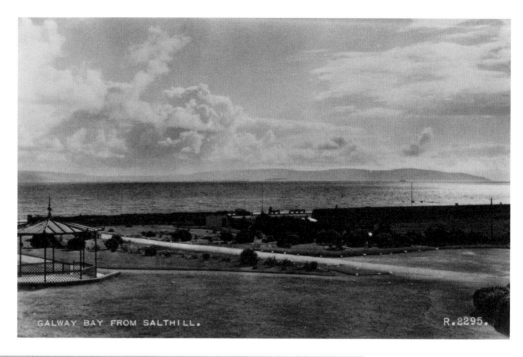

Salthill Park in the early 1950s. The ironwork for the bandstand was cast in Glasgow.

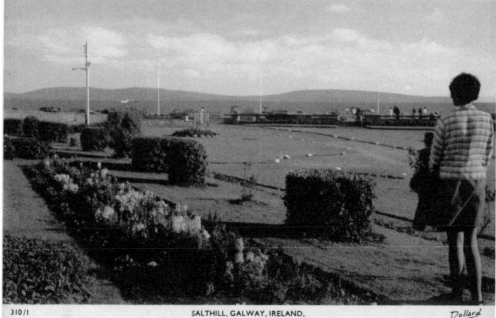

Salthill Park in the late 1950s.

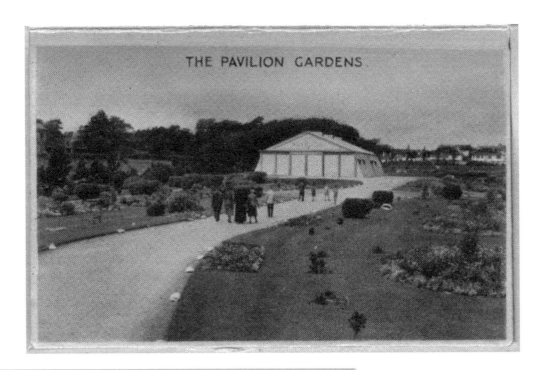

The Pavilion Ballroom, or Hangar as it was more popularly known, in the 1950s.

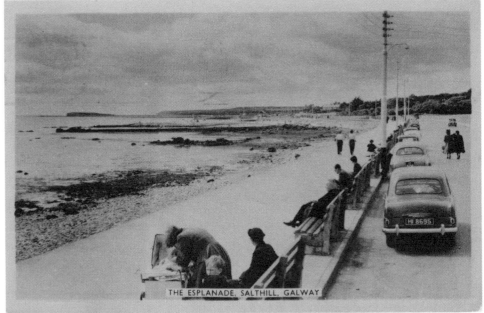

THE ESPLANADE, SALTHILL, GALWAY

The Promenade, c.1955.

The Promenade, looking east, in the late 1920s. Note the four large gate pillars.

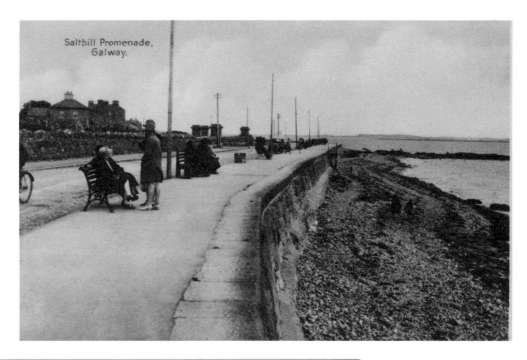

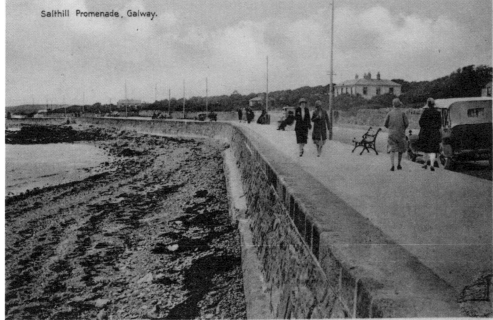

The Promenade, looking west, in the late 1920s.

The Promenade in the early 1950s.

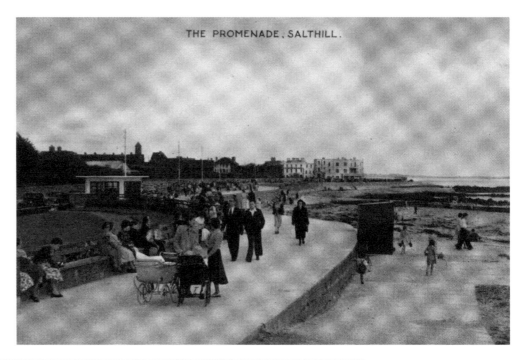

THE PROMENADE, SALTHILL.

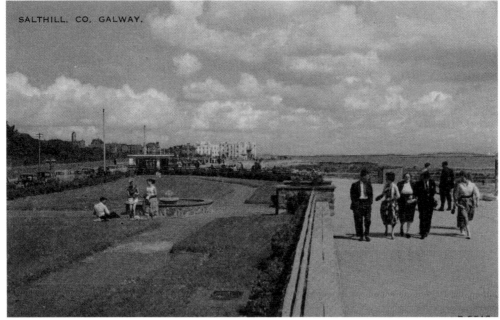

SALTHILL, CO. GALWAY.

The Promenade, c.1960. Note the ornamental fountain on the left. This was removed in the late 1990s.

The beach in the
early 1950s.

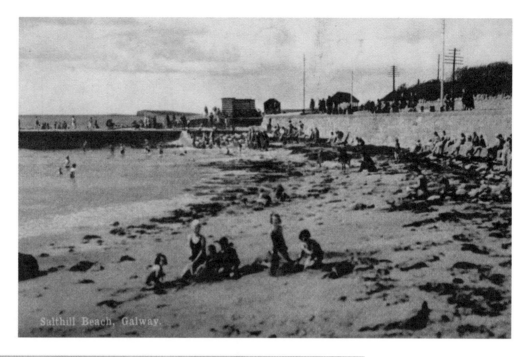

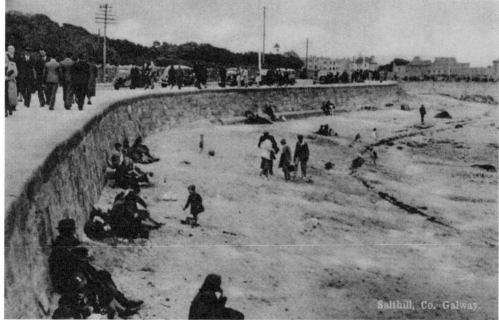

The beach and
promenade,
looking east, in
early 1950s.

The ladies' beach and bathing pool in the 1920s.

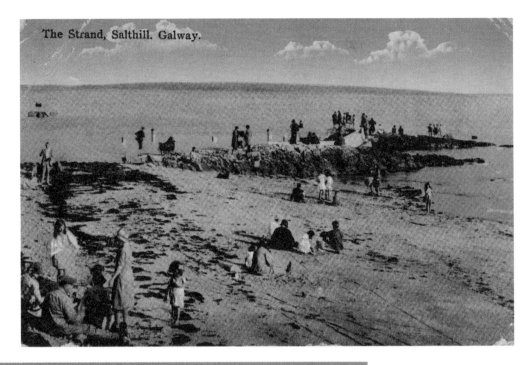

The Strand, Salthill. Galway.

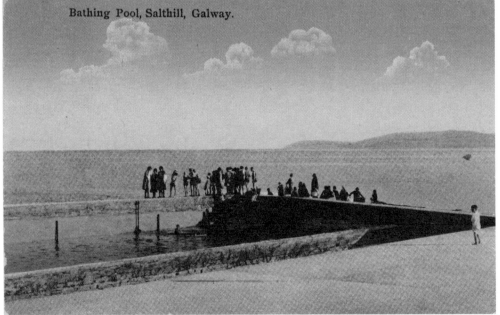

Bathing Pool, Salthill, Galway.

The bathing pool in the 1920s.

The bathing pool in use in the 1950s. The inner pool was the shallower of the two and was primarily for younger children.

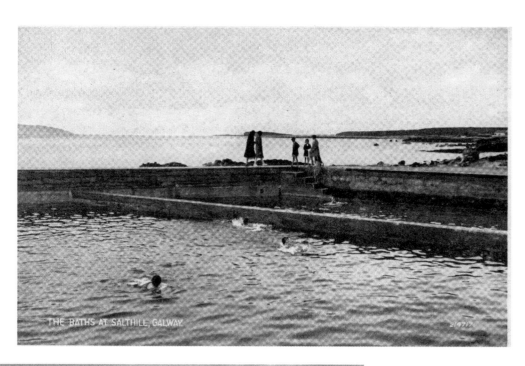

Looking east from Blackrock, c.1930.

Shingle Beach at
Blackrock, 1950s.

Men's bathing area,
Blackrock, c.1905.
Note the original
style of diving board.

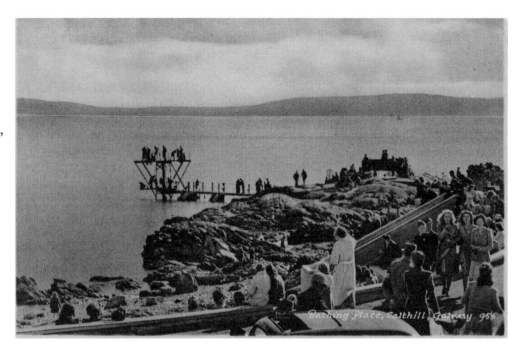

Men's bathing area, Blackrock, c.1950. Judging by the overcoats being worn, the photograph for this card was taken on a cold day. The second-generation diving facility is obviously in use.

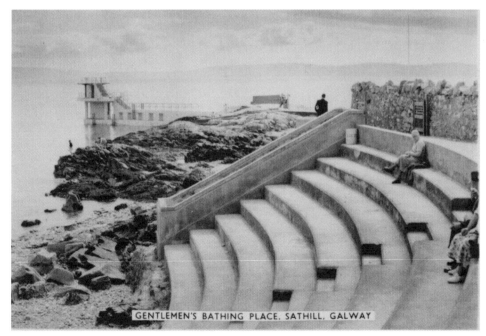

GENTLEMEN'S BATHING PLACE. SATHILL. GALWAY

The latest diving tower, c.1960. The tower was constructed in 1956.

A gala event in
Salthill, c.1948.
The band of
the Western
Command appear
to be supplying
the music.

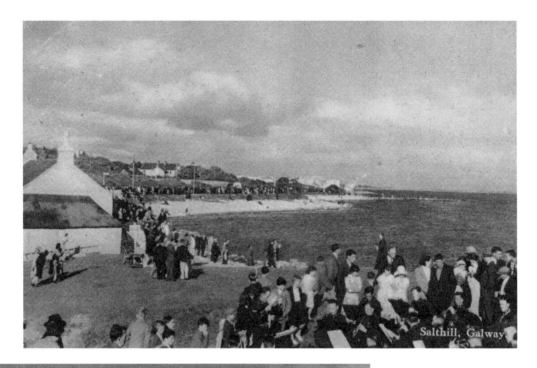

Blackrock,
early 1950s.

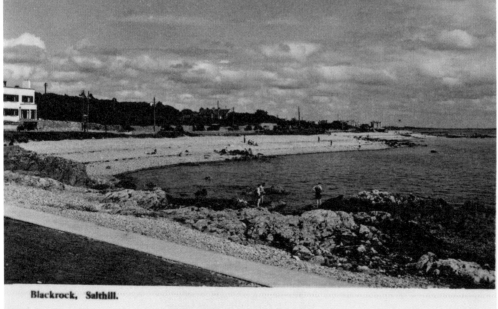

The Golf Links Hotel, later known as the Ocean Wave, c.1960.

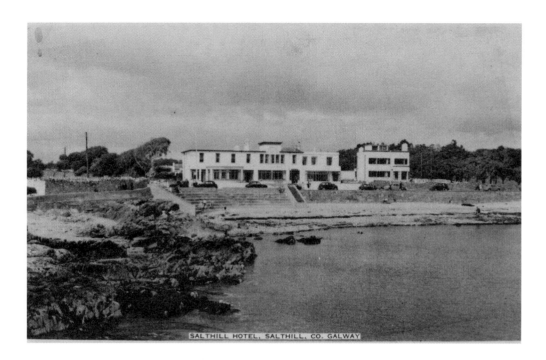

SALTHILL HOTEL, SALTHILL, CO. GALWAY

CHAPTER 9

A Meander from Threadneedle Road to St Patrick's via

Taylor's Hill, St Mary's, Henry Street, Presentation Road, Woodquay, Menlo and Renmore

Galway has had a long tradition of education. Its schools have a proud history, so it is not surprising that a number of them have appeared on postcards. St Enda's on Threadneedle Road is a case in point. It was originally established in Furbo as an all Irish school. Boys were prepared for a career in national school teaching. Because of its success in leaving certificate results it was decided to relocate in Galway where, as a boarding school, it could draw in pupils from all around the country. The new school was constructed by Stewarts of Salthill and opened in 1937. It became a day school in 1986 and subjects were taught through English. In 1991, the school went co-educational with the admission of female students. The photograph of St Enda's for the card was taken shortly before building works were completed. Contractor's sheds are still on site. The photo was taken from a high vantage point looking across the tennis club's site. The field in the foreground is now occupied by Salerno girl's secondary school.

The Dominican College in Taylor's Hill opened its doors for day pupils in 1858. The Dominican Sisters had acquired a small house called Sea View on Taylor's Hill in 1845. Their first Galway community was established in 1644. When Cromwellian troops moved into Galway in 1652 the nuns went into exile in Spain and stayed there until 1686 when they returned to the city. They had a convent in St Augustine Street for a while and subsequently moved to Kirwin's Lane before settling in Taylor's Hill. In 1859, Mount St Joseph's Boarding School was opened. Initially it had two boarders. As pupil numbers increased, extra buildings were needed. Finally, in 1896, work began on the construction of St Dominic's. The

building was designed by James Perry, county surveyor for the Western Division of County Galway. The new building was formally opened in 1901. It no longer serves as an educational centre, a new school having been constructed in 2007.

St Mary's College formally opened for the reception of boarders and day pupils on 26 August 1912. There were sixty boarders and seventeen day pupils. The building was designed by William Anthony Scott, professor of architecture in University College Dublin. Scott had previously designed the church in Spiddal. The design for St Mary's was a novel one. Art deco in style, it actually predated the art deco movement by ten years. The building was altered by the addition of an extra story in 1939, and at a later stage by an extension. The boarding element in the school was phased out and finally closed in 2003. The school was constructed by James Wynne of Dundalk.

While schools bring benefits of education to people, their construction brings employment. The employment may be short-term, but the services that have to be laid on may well carry a long-term benefit for the community. The new school could not have opened without a connection to the public sewerage system, which had to be extended to cater to the school. This meant that other developments could take place in the future.

St Mary's is located on a hill which commands a good view out over the city. Several postcards feature photographs taken from the top of the hill, both before and after the college was built. The early views (pre-1912) show a line of thatched cottages in Raleigh Row and Shell Lane. A huddle of cottages can be seen between Shell Lane and St Helen's Street. Following the collapse of some of these houses, the urban district council decided to construct a housing scheme in the area and rehouse the community in decent living conditions. The scheme had been drawn up when extra land was offered to the council, which meant that an increased number of houses could be constructed. The council raised a loan of £6,250 to finance the scheme. The later view from the hill shows a changed landscape. St Mary's Road, also known as the New Line, has a line of houses facing the college and all the thatched houses have gone. The New Line was constructed to link Lettle Street from Cooke's Corner to Nile Lodge. The first housing development along this road was Kirwan's Avenue named for the developer who had it constructed. The contractor who had the maintenance contract on the road had it revoked in 1912 because of neglect. Sometime after the college was opened, the roadway name was changed to St Mary's Road.

The Presentation Sisters were brought to Galway in 1815 by Dr French, warden of Galway. Three sisters arrived and established themselves briefly in Kirwin's Lane before moving on to Eyre Square. They stayed there for three years until 1819 when they acquired their present convent. It had originally been built as a charter school where Catholic children could be educated in the Protestant tradition. The school closed within a few years. The building was taken over by the British military for a period after the 1798 rebellion and used as an artillery barracks. In due course it became vacant again and was acquired by the nuns. By 1820, the sisters had opened a school adjacent to the convent. St Joseph's Church was built on the other side of the convent between 1882 and 1886 by direct labour, as financial resources were limited. Rev. Patrick Lally, the parish priest, was the driving force behind the project. The architect was William Hague, a noted church designer. He had also designed the Dominican Church in the Claddagh and the spire for Gort Church. The church contains a stained-glass window representing St Joseph, which was produced in the Harry Clarke Studios. The church came to international attention when one of the parish curates, Fr Michael Griffin, was murdered by the Black and Tans and his body buried in a bog. There was an enormous funeral despite the attempts of the British government to keep people away.

The National University of Ireland Galway was founded as the Queens College Galway in 1849, having its name changed to University College Galway in 1908 and then again to the current name in 1997. It was threatened with closure on three occasions because the student numbers were low. When the college first opened in October 1849, it had an enrolment of sixty-three students. The original college building, the Quadrangle, was designed by Joseph B. Keane. Keane worked for Richard Morrison, the noted Dublin architect, for a number of years before setting up his own practice. He designed several churches including Longford Cathedral. Keane's design for the college is believed to have been influenced by Christ Church College, Oxford. The Quadrangle building was constructed using stone from the Anglinham quarries. A considerable amount of material excavated during the construction of the Eglinton Canal was used to create the platform in front of the building. The college finally admitted women as students in 1888, but only to the facility of Arts. However, by the early 1900s women students were admitted to all facilities. Alice Perry, the world's first female civil engineering graduate, qualified from the college in 1906. Her father was James Perry, county surveyor for West Galway and co-founder of the Galway Electric Light Company. An intriguing item concerning the Galway Engineering School is that all the professors of civil engineering from the opening of the college have had some involvement with railway design or construction. Indeed,

Professor Townsend had an extended role in the saga of the Galway–Clifden Railway. In 1881, he chaired an enquiry into the proposed Galway, Oughterard and Clifden railway for the Guaranteed Light Railways and Tramways Company. He was also heavily involved in the design of two separate railways to Clifden for rival promoters.

Perhaps the most colourful career of any Galway professor was that enjoyed by William Henry Prendergast. He joined the Royal Engineers in 1916 and saw service in the Middle East. He returned from the war with the rank of major and joined the Bengal–Assam Railway. When Japan invaded Burma he was sent to Raugoon with a train to evacuate the 'last ditchers'. He organised an orderly withdraw of civil and military personnel and, when the train was derailed by enemy artillery fire, led his party safely northwards to India, under continuous enemy attack, without losing a single member of the group. He was awarded a distinguished service order. When the war ended and he again returned to civilian life, he became engineer-in-chief to the Assam Railway. He retired in 1947 and returned to Galway to take up the professorship of civil engineering vacated on age grounds by Professor Rishworth who had succeeded Townsend in 1910. Prendergast died in 1957.

In 1498, an attempt to link Lough Corrib to the sea by means of a navigable canal was attempted but soon abandoned. In the early eighteenth century an inland navigation from Galway to Ballina was proposed but never attempted. In 1830, Alexander Nimmo prepared plans for a canal to link the Corrib from above the site of the present weir to the sea as part of plans for proposed harbour. This proposal fell through also. However, when the first Corrib Drainage Scheme was proposed it included a canal. The scheme was constructed between 1848 and 1852. The canal was initially a moderate success. In 1857, some 6,825 tons of cargo was transported through the canal. This included mineral ore from the mines on the upper reaches of Lough Corrib. Seaweed for fertilizer was brought inland. In the early 1900s the annual tonnage averaged about 4,000 tons but by 1916 it had fallen away to practically nothing. The canal was spanned by five bascule bridges. Four of these were manufactured by the internationally famous Mallet foundry in Dublin. The fifth, Carlisle Bridge, at the entrance to the Claddagh Harbour, was manufactured in Galway by the Stephens' foundry. In 1954, the swivel bridges were replaced by fixed reinforced concrete structures designed by F.S. Rishworth and Ed Ralph Ryan, thus closing the canal.

Another Galway project that took a considerable time to bring to fruition was the construction of a cathedral. When the Diocese of Galway was established in 1831 the parish church in Middle Street

became its proxy-cathedral. A fund to build a proper cathedral was instituted in 1876. In 1909, Bishop O'Dea had plans for a cathedral drawn up by William Anthony Scott but changed his mind and had St Mary's College, also drawn up by Scott, constructed instead. Attention soon shifted to the site of the Shambles Barracks in Bridge Street. The site was acquired and alongside it an extra area of ground, and Bishop Michael Browne decided on this location as the site for the cathedral. Wiser heads prevailed, and the site was utilised instead for St Patrick's National School. In 1941, the site of the old county prison was acquired and, in 1949, John J. Robinson of Dublin was appointed architect. The interior buildings of the old jail had been demolished by then, only the outside boundary wall and gatehouse were left standing. The gatehouse faced directly across the Salmon Weir Bridge to the rear of the courthouse. Public executions were held at the gatehouse but eventually the outer gates were closed and the public viewing was eliminated. In 1848, some 485 died of famine-related causes within the confines of the former county prison. Work began on the construction of the building in February 1958 and was completed by May 1965. The cathedral was dedicated on Sunday 15 August 1965 – the feast of the Assumption. Cardinal Cashing as Papal Legate dedicated the cathedral and Cardinal Conway celebrated the Pontifical High Mass.

The Salmon Weir Bridge was never formally named. It had been known as the New Bridge, the West Bridge, the New Bridge in the West, the Jail or Gaol Bridge, the Weir Bridge and finally the Salmon Weir Bridge. The construction of the bridge took some sixteen months, work being commenced on Monday 29 June 1818 and completed by October 1819. The contractor was Behan, who had constructed the nearby county prison under the supervising architect Richard Morrison. Morrisson designed the county courthouse so there is the possibility that he had an input into the design of the bridge. The financial arrangements for the construction of the bridge required the prison trustees to contribute one sixth of the costs out of their funds. This, coupled with the fact that the setting of the structure created a totally unnecessary dog-leg bend in the public roadway for anyone travelling along what is now St Vincent's Avenue, indicates that penal or prison concerns came before public convenience. It would appear that the bridge was Galway's 'Bridge of Sighs'.

The county courthouse was constructed on the site of the former Franciscan abbey. After the reformation the abbey was used as a courthouse for a while. The judge's seat was on the site of the high altar. In 1645, the abbey was again in Catholic hands but when the town was surrendered to the Cromwellians, things

changed drastically. In 1657, all the Abbey buildings were demolished. In the 1780s, part of the site was used as a malt house. In 1812, the site was cleared and work began on Richard Morrison's courthouse. It was completed in 1815, some time before the bridge was constructed. Shortly after work began on the new courthouse, Morrison was embroiled in a lawsuit for criminal conversation (adultery in layman's terms) taken against him by John Aylward of Ballynagaw House, a former client. It didn't seem to affect Morrison's business. The building was altered internally on a number of occasions. An extension to the rear blocked off the old rear entrance which faced directly across the bridge to the entrance gate to the county prison. The last major courthouse refurbishment took place in 1995 under the direction of John Yates.

The Franciscan church is located near the site of their original abbey in Galway. There is some doubt as to when work began on the construction of the church. In 1820, work began on the friary house and both it and the church were completed before 1836. The abbey, or the Church of the Immaculate Conception to give it its proper name, was made parish church in 1971. The church was the first in Ireland to bear the name, and was dedicated four years before the dogma was pronounced. The Cromwellians weren't the only persecutors the Franciscans had. Father Peter Daly seemingly hated them. As a power-hungry cleric, he no doubt saw them as being outside the scope of his potential control. Daly did achieve a lot for the town but seemed to create controversy at every turn. He invited the Sisters of Mercy to Galway and set up a convent for them in Newtownsmith on part of the site of a disused distillery, which had been operated by James and Patrick Joyce. The Joyces had a long involvement in distilling in Galway prior to getting into financial difficulties in 1840. They were in occupation of the Newtownsmith site in 1785 and possibly earlier. They had offered the distillery for letting in 1823 but were still working on it in 1828. The gable of the chapel can be seen to the right on the card featuring a view of the Salmon Weir Bridge looking upstream from Newtownsmith.

Many cards featuring the Salmon Weir Bridge give tantalising glimpses of Galway's industrial heritage. The Newtownsmith and Bowling Green areas often provided the backdrop to the bridge. These areas had a large concentration of water-powered industries. The woollen mill nearest the convent was originally a flour and meal mill with a very large mill pond. The pond was on the site of the school yard and the school occupies the site of the mill. The mill was owned by a Mr Hugh Hannon in the 1870s. The mill had closed by the end of the century. The site was acquired by Father Dooley on behalf of the diocese, and a woollen mill was opened in 1903. It gave much-needed employment, although the wages were not good – 18s per

week for the men and 7s 6d for the women. The mill was acquired by Flynns of Sixmilebridge, County Clare. By then, about two hundred people were employed and wages averaged £3 per week. The company supplied material for army uniforms during the emergency. The mill closed in 1957 and the building was destroyed by fire in 1960. The hosiery factory was located across the road. Most of its employees were female – about fifty in total. It had a large export trade to Scotland. The hosiery factory site eventually became part of the Electricity Supply Boards premises at Newtownsmith.

The Galway Electric Company Limited was established with James Perry as managing director. The Perrys had established a generating station in Newtownsmith in 1888. This gave an electric power supply to some private customers. The works were extended in 1889 and new machinery installed. In 1897, the Perrys established the Galway Electric Company. By 1904, they had successfully tendered for the contract to light the streets of Galway. For a brief period in the winter of that year, both gas and electricity were in use until all the electric lighting standards were erected. The company survived until 1929 when it was taken over by the Electricity Supply Board, which had been set up to run the electrification scheme for the Irish Free State. The ESB subsequently sold on the premises, and the site is now occupied by a shopping complex. The site adjoining this is now a car park but, in the nineteenth century, was home to a large brewery. Next door to this was a skinner's yard, run by the Ms Gunnings in the 1820s, and a tannery. The workers in the bark mill (used to make tannin from tree bark) often threw the spent bark into the Queens gap in the weir to trap salmon. Beside this was Gunning Flour and Meal Mill, which later became the City of Galway Woollen Company's mill.

The Salmon Weir Bridge was extended on the west side by the addition of an extra arch to cater for the Newcastle Stream, which served as the tail race for Persse's Newcastle Distillery and the bleach mill (later the site of the bag factory). This arch was inserted during the drainage works of the 1850s. The bed of the main river was lowered by the excavation of a huge amount of rock. This meant that the piers of the bridge had to be underpinned or propped. When the second drainage scheme was undertaken, between 1955 and 1959, it was decided that the riverbed should be lowered by another three feet. Accordingly, the bridge had to have further underpinning carried out. The depth of the excavation that was undertaken in the two drainage schemes can be judged for the height of the concrete visible under the piers.

During the execution of the first drainage works, a regulating weir had to be constructed. As its name implies it was built to control the river level in the interest of drainage, navigation and milling. Two large

sluices were installed. The ironwork for these was manufactured in Stephen's Foundry, Merchants Road. When the second drainage scheme was proposed, it was decided that a new, more efficient weir with extra sluices should be constructed.

Work started on the new weir in 1955. To gain access to the site for excavation purposes, a temporary roadway had to be constructed in the riverbed, a portion of it is shown on at least one postcard. A significant amount of water was needed to ensure water power for the various mills, breweries and Burke's Distillery at Quay Street. During the first drainage works, a major embankment was constructed from the east end of the weir running alongside the river to convey a flow of water at a sufficient height to drive the water wheels in these establishments. The embankment now serves as a riverside walkway.

The Corrib has been famous as a salmon fishery for centuries, so, when both drainage schemes were underway, care had to be taken not do damage to the extremely valuable asset. The fishery was purchased by Thomas and Edmond Ashworth in 1852. They set about improving fish numbers immediately and set up a hatchery in Oughterard so that the Corrib system could be restored. A fish pass had to be installed in the weir to allow fish to travel upstream to spawn in the tributaries feeding into Lough Corrib. The fisheries house was constructed for the manager of the operation.

The Corrib provided Galway with a water supply, a source of food, a transport route and power for its industries. However, it also created a barrier for those wishing to construct a railway into Connemara. Early proposals called for the construction of horse-drawn trams which could use the city streets and be light enough to cross the Salmon Weir Bridge. The expense of constructing a large railway bridge capable of carrying steam engines was considered to be too much for a line to serve a thinly populated area. However, the sweetener of a free grant of £264,000 towards the construction costs in 1890 ensured that the Galway–Clifden Railway was constructed. It took five years to complete the line. The Corrib viaduct was the largest single structural item; it had three spans, each of 150 feet, and a bascule lifting span of 21 feet. The line closed in 1935 and the superstructure of the bridge was demolished. The steel was sold as scrap to Hammon Lane Foundry, Dublin, who are believed to have sold it on to Krupps in Germany. The piers of the bridge were left standing. Various plans were put forward to have a pedestrian bridge built at this location. One such bridge was designed for a Millenium project to be undertaken in 2000 but objections stymied the project.

As part of the conditions for allowing the railway company to construct the bridge, the Corrib Navigation Trustees sought a new harbour for Woodquay. The existing harbour was composed of two timber jetties, one of which would be interfered with by the construction of the viaduct. The present day masonry harbour was constructed and also the roadway leading down to it. Lough Corrib had become very popular for excursions thanks to the steamer traffic that plied the lake. One such steamer was the *Countess Cadogan*. She had been built in Paisley, Scotland by Bow McLachlan in 1897 and sold to the Shannon Development Company, an organisation that was heavily subsidised by the ratepayers of every county bordering on the river. In 1913, she was sold on to the Corrib and steamed up the west coast from Limerick to Galway. In 1917, she was withdrawn and sold to Nicholas Cook of Aberdeen. The *Countess* was still registered as a working boat at Lloyds in 1930.

Menlo Castle was a popular spot for locals for 'Maying'. It is not known when exactly this custom started but it was certainly an annual event before the Famine. The *Galway Vindicator* for 5 May 1852 remarked that 'the old and time-honoured custom of Maying at Menlo was observed on last Sunday when the attendance was much larger than usual. The working classes took advantage of their short relaxation from labour and joined the rural sports with a hilarity which indicated a return of the good old times.' The report goes on to say that the temperance band gave an admirable performance and lake-paraded through Galway. There was a large turnout of 'the gentry and respectable inhabitants of the town'. The sports were expected to last for another three Sundays. Menlo Castle was home to the Blakes from about 1600 onwards. It was destroyed in a fire in 1910.

If Maying at Menlo was popular, it was as nothing compared to the races. In 1760, racing was conducted at Loughrea, and at an earlier date in Eyrecourt. The first race meeting at Ballybrit was held on 17 August 1869, when some forty-thousand people are reported to have attended the two-day event. The course was laid out by an engineer, a Mr Waters.

While the Ballybrit racing has gone from strength to strength and has always been, for most people, a joyful friendly occasion, racing in Galway was not always so. Seemingly a racing contest finished up in a trial in the county courthouse in 1845. Michael Kelly claimed a racing cup and stakes which Lieutenant Young of the Athlone garrison refused to give up. His reason, as a sore loser, was that one of the rules stipulated that the horses were to be ridden by gentlemen. The stewards sided with the Lieutenant, who had come in second to Kelly. It was established in court that Kelly rode the winning horse and his counsel

set out to prove him a gentleman within the definition contained in Blackstone's *Commentaries on the Laws of England*. This read that any man who could 'live idly and without manual labour, and will bear the post, charge and countenance of a gentleman shall be called "master" and accounted for a gentleman'. Young's counsel called witnesses to prove that he had been visited by Lady Clanricarde at his house and, accordingly, Kelly could not consider himself the social equal of Young. James Skerrit of Carnacrow swore that Kelly was not a gentleman as his father was not one before him. He was asked did he know that the Lord Chancellor's father was a barber. When he answered in the affirmative he was asked was the said lord a gentleman. He replied that he most certainly was not. The case was put to the jury, who found for Kelly awarded him the prize and his costs.

Renmore Barracks was constructed in 1881 on land purchased by the British War Department in 1852, the year after the railway system reached Galway. The land was used as a summer training ground and artillery range for many years. After the buildings were completed, the barracks became the depot for the Connaught Rangers. The regiment spent most of its time abroad serving in various British colonies, particularly India. New recruits were trained in the depot, which was the administrative headquarters for the Rangers. A group of Connaught Ranger recruits at rifle drill were carefully posed for the Laurence Company photographer. No doubt the card was seen as an aid to recruitment. In June 1922, the barracks was vacated by the British army and handed over to the Irish Republican army. When the Civil War broke out, Republican forces burnt the barracks. When the Irish army was reorganised in 1924, the First Battalion was made an all-Irish battalion, *An Chead Cath*, and headquartered in Galway.

The barracks was renamed Mellows Barracks in honour of Liam Mellows, commander of the Galway IRA during 1916. Mellows was shot by the Free State government, along with three other republicans, in reprisal killings for the shooting of Sean Hales.

Initially, when the Rangers moved into Renmore Barracks, they had no church. The vast majority of the regiment were Catholic, so they had to parade into town every Sunday for Mass. They would not have been able to attend Mass in St Patrick's Church as it was closed and in use as a commercial hall. The story of the church is rather convoluted. When the Diocese of Galway was established in 1831, Galway was divided into four parishes, all sharing a common central parish church – St Nicholas'. The new parish priest for Bohermore was Fr Bartholomew John Roche, who set out to built a parish church on a site in that section of College Road that has since been renamed as Forster Street. Fr Roche toured Britain in

1835 gathering some money. The foundation stone for St Patrick's was laid on 17 May 1836. Further fundraising trips were undertaken as building works progressed. However, on 6 January 1839, 'The Night of the Big Wind', the roof of the new building was swept away. Despite this setback, the new church was dedicated on 11 January 1842. The Jesuit order took over the church in 1859. When their church was opened in Sea Road in 1863, they vacated St Patrick's. By then the parish church was at the centre of legal problems. The site was composed of various plots of ground, some of which were held on short leases. When the lease of the plot in front of the church expired the property owner refused to renew it, and erected a wall cutting off access to the church, which was then converted into a temperance hall, where concerts and evening adult education classes were held. Renewed efforts to renegotiate the lease in 1870 failed, and the building became somewhat dilapidated and was converted to commercial use. Finally, in 1897, the plot of ground was sold to the church and it was decided to renovate the building. It was rededicated on 13 March 1898. By then, the Rangers had their own church at Renmore. St Patrick's had a distinctive spire but, unfortunately, the top story had to be removed in 1936 due to structural defects. The church was replaced by the new St Patrick's in 1972, its slender belfry visible from the square as was the top of the spire of the old St Patrick's.

St Enda's, Threadneedle Road, shortly before the construction work was fully completed in 1936.

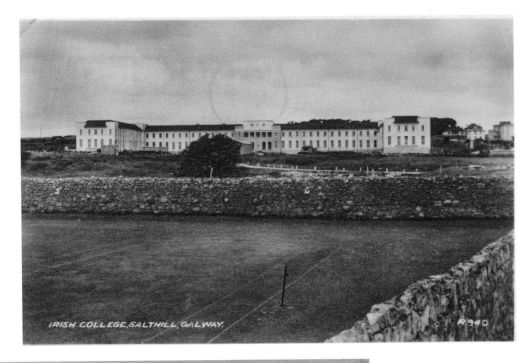

Taylor's Hill Boarding School for girls, c.1900.

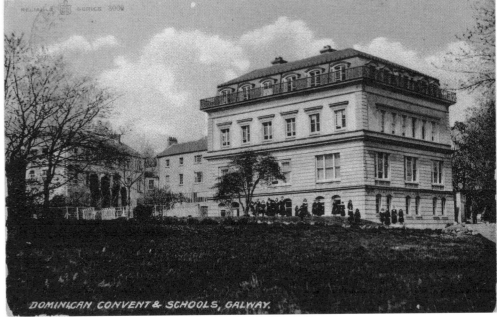

Galway composite view card featuring the newly constructed St Mary's College.

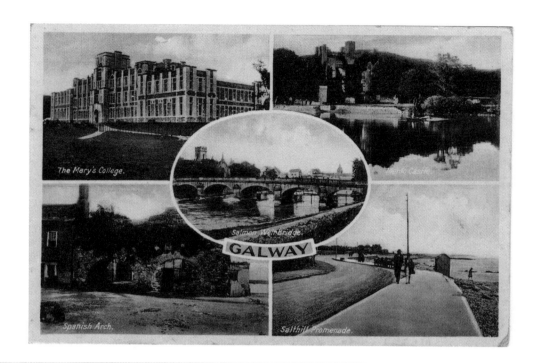

Galway Urban District Council notification of meeting to sanction loan application for sewerage scheme works, 1912.

URBAN DISTRICT COUNCIL,

Office, Galway,
28th May, 1912.

Sir,

I beg to inform you that Mr A. D. Price Engineer Inspector, Local Government Board, will hold an Inquiry at the Council Room, County Buildings, Galway, on Wednesday, 29th inst., at 11 30 o'clock, a.m., into the Council s application for sanction to a loan of £302, for the purpose of extending the sewerage system at Shantalla Road.

I am, Sir,
Your obedient Servant,
T. N. REDINGTON.

General view of Galway, c.1905, from the hilltop that was later used as the site for St Mary's College. The thatched houses on the left were later demolished. The 'New Line', later St Mary's Road, is in the foreground.

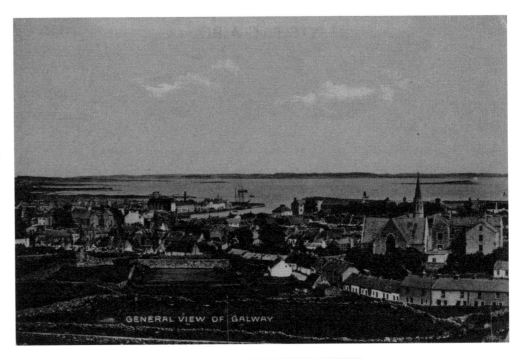

GENERAL VIEW OF GALWAY

URBAN DISTRICT COUNCIL OFFICE,

GALWAY, 18TH MARCH, 1913.

SIR,

I beg to inform you that at the Adjourned Meeting of the Galway Urban District Council to be held at the Council Room, County Buildings, Galway, on Thursday, the 20th day of March, 1913, at the hour of 12 o'clock, noon, Tenders will be considered for the erection of 40 Houses at Henry Street.

I am, Sir,
Your odedient Servant,
T. N. REDINGTON,
Secretary.

Galway Urban District Council notification of meeting to consider tenders for Henry Street. Houses to be constructed on the site of the thatched houses shown on the previous card.

General view of
Galway taken
from St Mary's
College, c.1950.

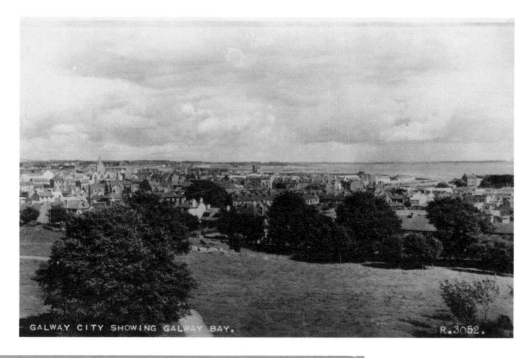

Presentation
Convent, c.1900.

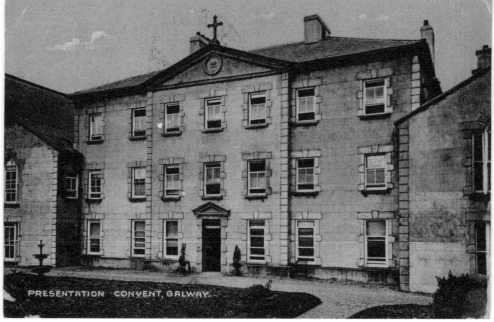

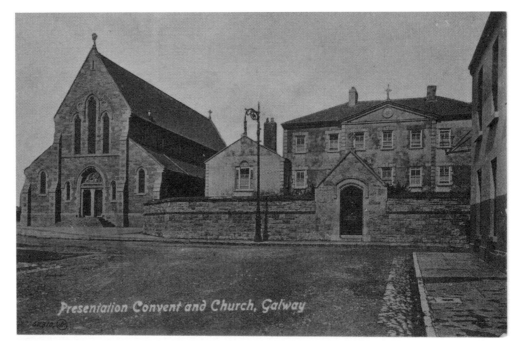

St Joseph's Church and Presentation Convent, c.1910. Note the wall-mounted holder for gas light on the building on the right-hand side and the electric light standard in centre.

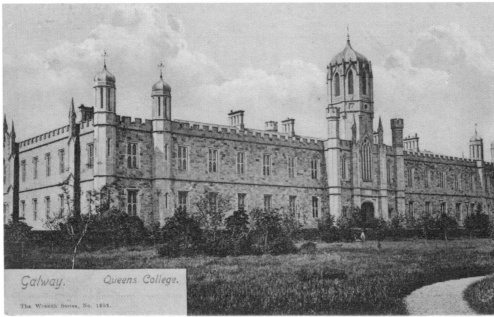

University College, c.1870. Note the student in the white breeches, frock coat and hat standing beside the embankment in front of the archway.

University
College, c.1905.

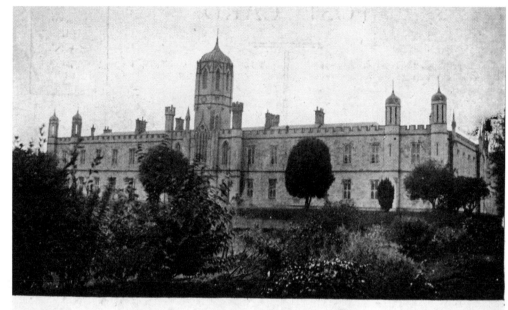

Queen's College, Galway

Photo by Hare, Galway

THE QUADRANGLE, GALWAY UNIVERSITY.

The Quadrangle,
c.1950.

The entrance to the
Eglinton Canal,
early 1950s.
The rebuilt Royal
Yacht Club premises
are on the right and
the former Persse's
Bonded Stores,
later I.M.I. factory,
is on the left.

River Corrib, Galway.

The dedication Mass
for the cathedral
held on Sunday,
15 August 1965.

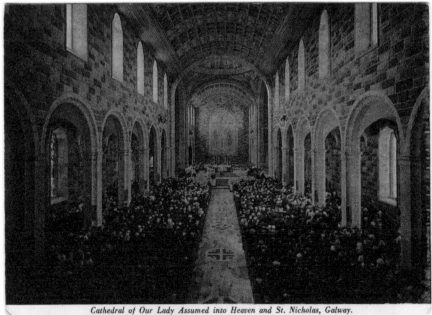

Cathedral of Our Lady Assumed into Heaven and St. Nicholas, Galway.

The Salmon
Weir Bridge
and courthouse,
c.1895.

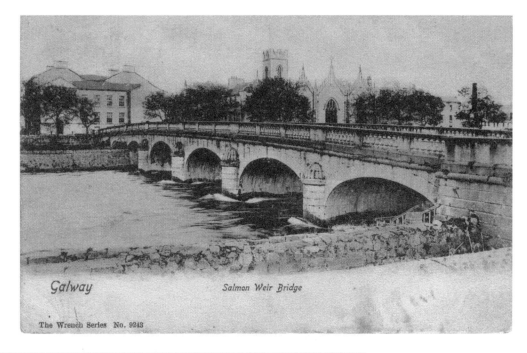

Galway County
Courthouse,
c.1950.

The Abbey,
c.1950.

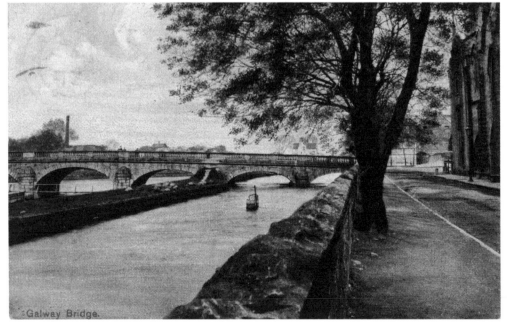

The Salmon Weir
Bridge looking
upstream from
Newtownsmith,
c.1900.
The eastern conduit
carrying water to
the mills in Bowling
Green and then
down to Burke's
Distillery flows
between the road
and the main river.

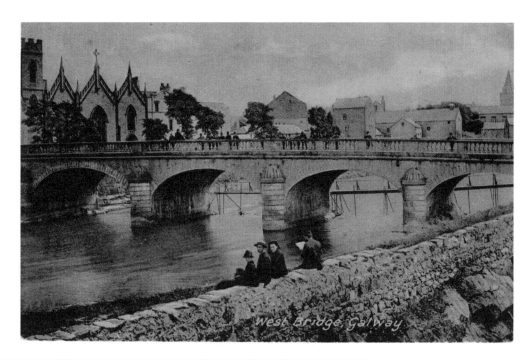

Looking across the Newcastle Mill Stream towards the Salmon Weir Bridge, c.1900. Fr Daly's Chapel, the woollen mills, the hosiery factory and the Galway Electric Company premises are in the background.

Looking down river towards the Salmon Weir Bridge, c.1925. The large building towards the centre was the City of Galway Woollen Manufacturing Company's mill.

The Salmon Weir Bridge with chimney of woollen mills and hosiery factory visible in the background.

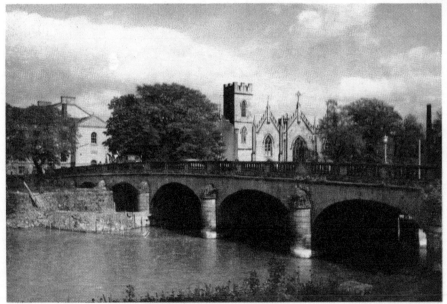

Salmon Weir Bridge in 1957. Showing part of a temporary road under construction in the riverbed as part of the Corrib drainage works.

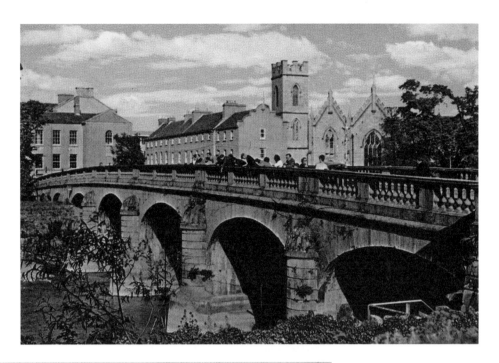

Salmon Weir Bridge, c.1960. Showing the courthouse, convent and Fr Daly's Chapel. The height of the concrete underpinning of the piers gives a good idea of how much the riverbed was lowered as a result of drainage works.

Lawrence, Photo, Dublin.

Salmon Weir, Galway.

Woodquay from above the weir, c.1890.

Woodquay from
the fisheries
house, c.1900.

Salmon moving
upstream, c.1935.

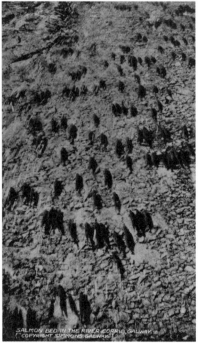

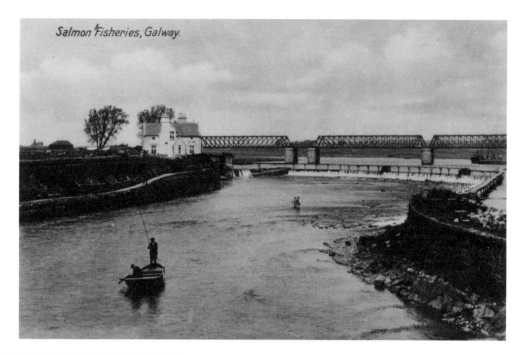

Salmon Fisheries, Galway.

The 1850s regulating weir and Corrib viaduct provide a backdrop for anglers, c.1910. A small steamer is visible under the bridge on the right-hand side of the picture, with some intending passengers standing on Steamers Quay.

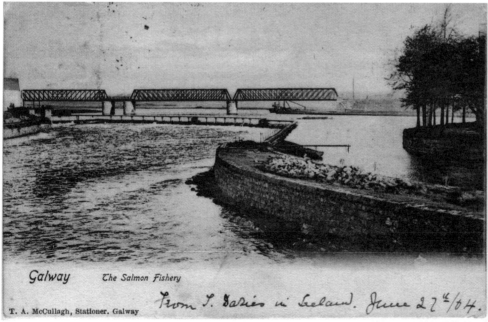

Galway The Salmon Fishery

T. A. McCullagh, Stationer. Galway

A wintertime view of the weir in flood and the Clifden railway viaduct, c.1895. A cargo steamer is at the quay.

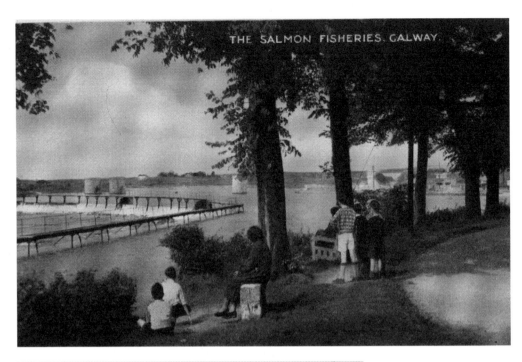

The regulating weir with the pillars of the viaduct (which was demolished in 1935), photographed from Woodquay about 1950.

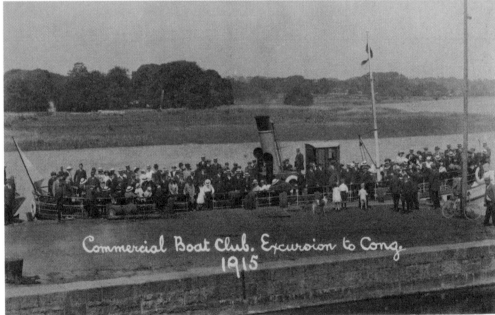

The *Countess Cadagan* with its passengers ready to steam to Cong, 1915.

A view of Menlough Castle from Dangan, looking across the Menlough Shoal.

A close-up view of Menlough Castle, c.1905.

The ruins of
Menlough Castle
viewed from
the old nunnery
at Dangan.

MENLO CASTLE AND CORRIB RIVER, GALWAY.

208311

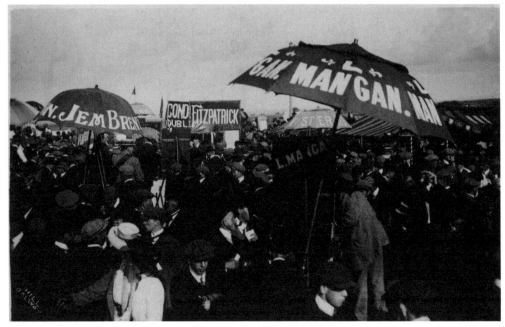

Galway Races, c.1910.

The Connaught Rangers at Renmore Barracks, c.1895.

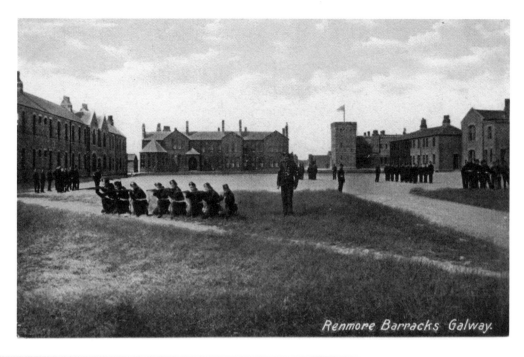

Renmore Barracks, c.1910.

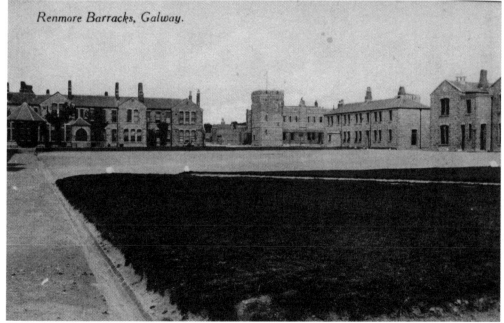

St Patrick's
Church, c.1905.

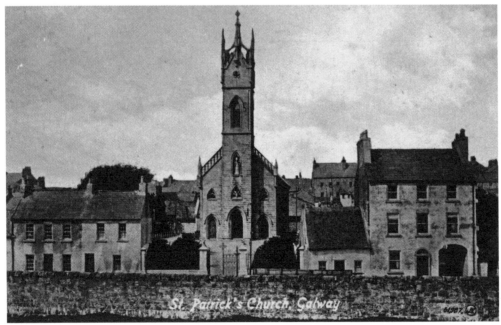

St Patrick's Church
and part of Forster
Street, c.1905,
photographed from
the fair green.

152

Primary Documents
Minutes of Galway Urban District Council, 1902–15.

Newspapers
City Tribune
Connaught Journal
Connacht Tribune
Connacht Sentinel
Galway Express
Free Press
The Independent
Galway Vindicator
Tuam Herald

Newspaper History Columns
Henry, William, 'Talking History', *Galway Independent*.
Kenny, Tom, 'Old Galway', *Galway Advertiser*.
O'Dowd, Peadar, 'Heritage of Galway', *Connacht Sentinel*.
O'Gorman, Ronnie, 'Galway Diary', *Galway Advertiser*.

Books, Pamphlets, Journal Articles
Arthure, J. B., 'Construction of a Sluice Barrage on the River Corrib at Galway', *Transactions of the Institution of Civil Engineerings of Ireland*, 87 (1960–1), pp. 21–44.
Berry, J. Fleetwood, *The Story of St. Nicholas' Collegiate Church* (2nd edn, Galway, 1989).
Cunningham, John, *A Town Tormented by the Sea: Galway, 1790–1914* (Geography Publications, Dublin, 2004).
Duffy, Paul, 'Aspects of the Engineering History of the West Region', *The Engineers Journal*, 40/8 (1986).
— 'Galway's Gaols', *Dlí: The Western Law Gazette*, 8 (Winter 1993), pp. 28–31.
— 'Random Notes on Galway's Courthouses', *Dlí: The Western Law Gazette*, 9 (Spring 1995), pp. 33–6.
— 'On Engineering', Foley, Tadhg, ed., *From Queen's College to National University: Essays on the Academic History of QCG/UCG/NUI, Galway* (Four Courts Press, Dublin, 1999).
— *Galway History on a Postcard* (Currach Press, Dublin, 2013).
— 'An Introduction to the Engineering Heritage of the Tuam Area', Tierney, Anne, et al., eds., *Glimpses of Tuam through the Centuries: Proceedings of a Seminar, 28th September 2013* (Old Tuam Society, Galway, 2013).

Dutton, Hely, *A Statistical and Agricultural Survey of the County of Galway with Observations on the Means of Improvement* (Royal Dublin Society, 1824).

Hardiman, James, *The History of the Town and County of the Town of Galway* (Dublin, 1820).

Henry, William, *Role of Honour: the Mayors of Galway City 1485–2001* (Galway City Council, 2002).

Historical Publishing Company, Industries of the North: One Hundred Years Ago (The Friar's Bush Press, Belfast, 1986).

Kenny, Tomás, *Galway Politics and Society 1910–1923* (Four Courts Press, Dublin, 2011).

May, Tom M., *Churches of Galway, Kilmacduagh and Kilfenora* (Galway, 2000).

Mac Donncha, Frederic, OFM, *The Abbey of St. Francis Galway* (Galway, 1971).

McNeill, D. B., *Coastal Passenger Steamers and Inland Navigations in the South of Ireland* (Belfast, 1965).

Mitchell, James, St. Patrick's (Galway, 1972).

Monaghan, Joseph, 'A History of Eyre Square', *Galway's Heritage Autumn*, 6, pp. 10–13; 7, pp. 21–2; 8, pp. 27–9; 9, p. 24.

Murray, James P., *Galway: A Medico-Social History* (Kenny's Bookshop & Art Galleries Ltd., Galway, c.1996).

Naughton, Mary, *The History of Saint Francis Parish* (Corrib Printers, Galway, 1984).

O'Cearbhaill, Diarmuid, ed., *Galway: Town & Gown 1484–1984* (Gill and Macmillan, Dublin, 1984).

O'Dowd, Peadar, *Old and New Galway* (Galway, 1985).

— *Down by the Claddagh* (Galway, 1993).

O'Heideain, Eustas, OP, *The Dominicans in Galway* (Galway, 1991).

Rothery, Sean, *Ireland and The New Architecture* (Lilliput Press, Dublin, 1991).

Rowan, Ann Martha, ed., *The Architecture of Richard Morrison and William Vitruvius Morrison* (Irish Architectural Archive, Dublin, 1989).

Ryan, J. H., 'The Galway and Clifden Railway', *Transactions of the Institution of Civil Engineerings of Ireland*, 28 (1902), pp. 203–35.

Rynne, Etienne, *Tourist Trail of Old Galway* (Galway, 1977, 1978, 1985, 1989).

Semple, Maurice, Reflections on Lough Corrib (Galway, 1973).

— *By The Corribside* (2nd edn, Galway, 1984).

— *Where the Corrib River Flows* (Galway, 1988).

Shepherd, Ernie, *The Midland Great Western Railway of Ireland* (Earl Shilton, 1994).

Villiers-Tuthill, Kathleen, *Alexander Nimmo and The Western District* (Connemara Girl Publications, 2006).

Walsh, Paul, *Discover Galway* (O'Brien Press, Dublin, 2001).

—'Galway: A Summary History', Fitzpatrick, Eliizabeth, et al., eds., *Archaeological Investigations in Galway City, 1987–1988* (Wordwell, Bray, 2004).

Wilkins, Noel P., Alexander Nimmo, *Master Engineer 1783–1832* (Irish Academic Press, Dublin, 2009).